SUNSHINE STITCHES

Mastering Summer Crochet Creations

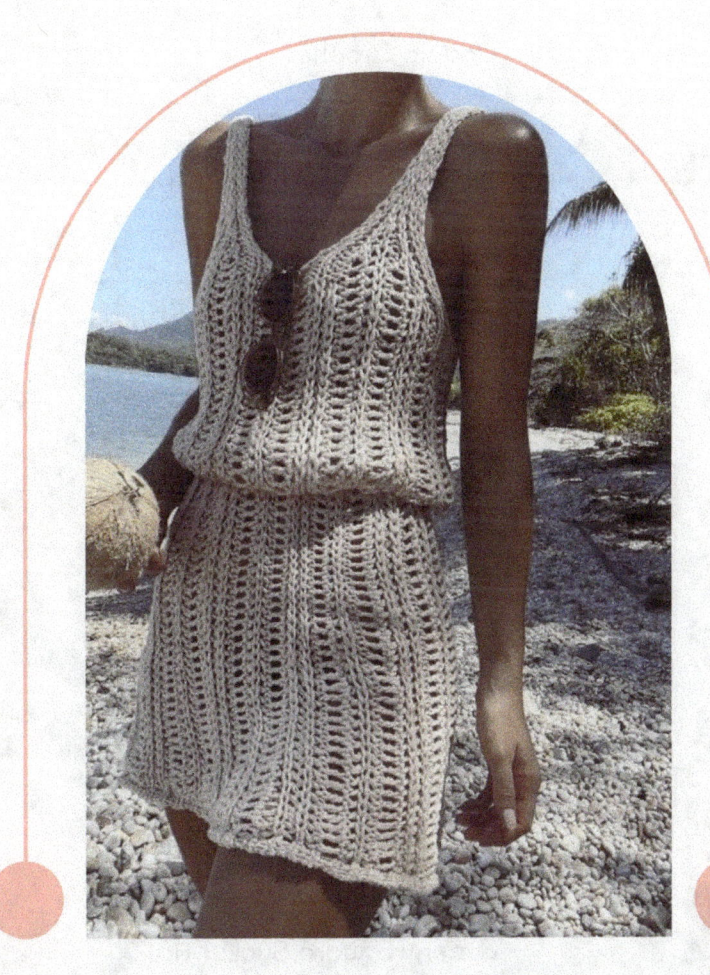

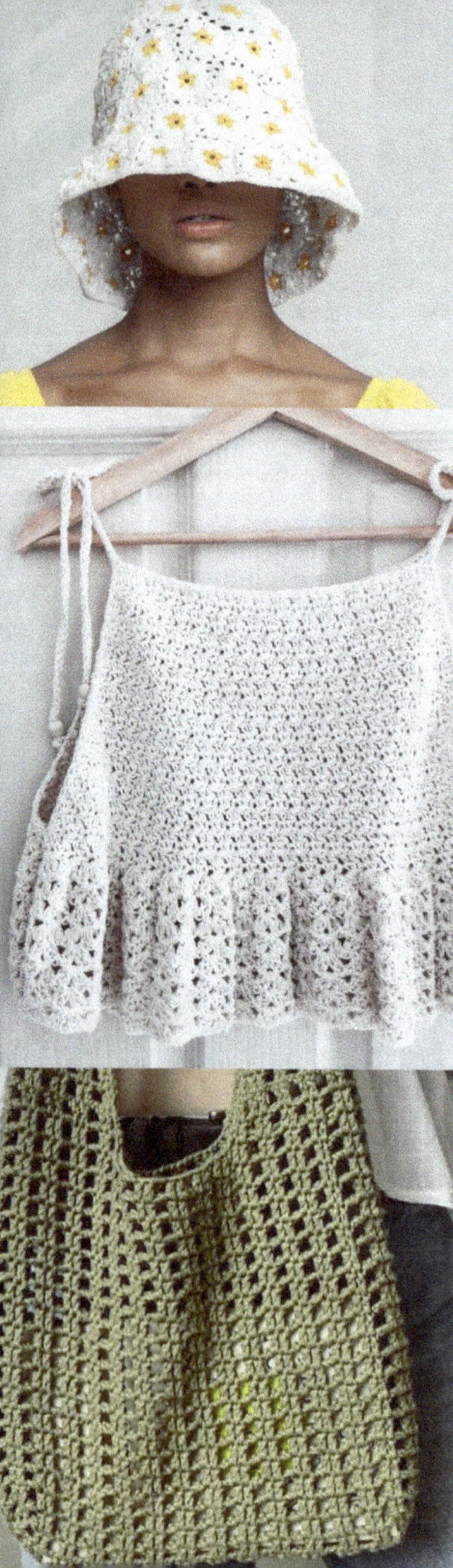

Contents

INTRODUCTION ... 1

STITCHES ... 4

 Chain stitch ... 6

 Single crochet ... 7

 Double Crochet .. 8

 Half Double Crochet 9

 Treble Crochet ... 10

ABBREVIATION .. 11

SUMMER ESCAPE PATTERN 14

 Chasing Summer Tank Top 15

 Granny Squares Vest 24

 Butterfly Top ... 30

 Catalina Crop Tank 40

 Colette Monokini Swimsuit 46

 Beach cover-up 55

 Scallop Summer Dress 61

 Starburst Tote Bag 75

 Raffia Summer Bag 83

 Granny Square Bucket Hat 90

 Summer Breeze Bandana 96

 Oopsy Daisy Bandana 102

Introduction

Welcome to the world of Sunshine stitches: Mastering Summer Crochet Creations! In this book, you will embark on a journey of creativity and relaxation as you explore the art of crochet in the sunny season. Whether you're a seasoned crochet enthusiast or a beginner looking for a new summer hobby, this book is your ultimate guide to creating beautiful, breezy crochet designs that are perfect for the warmer months. Get ready to unwind, unleash your creativity, and crochet your way to a blissful summer escape.

Included are patterns for: tops, beach cover-up, dress, hat, bags and bandanas.

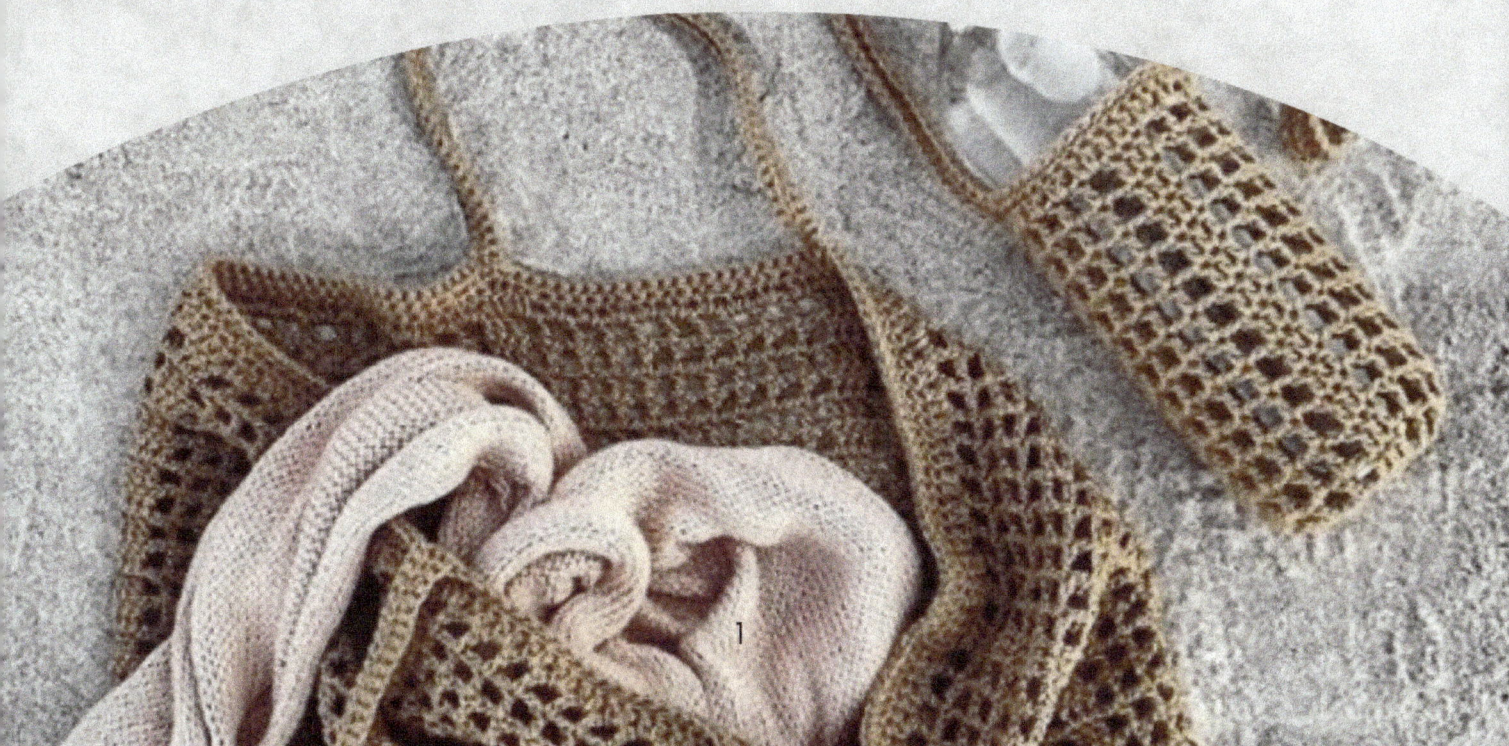

What is crochet

Crochet is a popular handicraft that involves creating fabric from yarn, thread, or other materials using a crochet hook. It is a versatile and creative craft that allows for the production of a wide variety of items such as clothing, accessories, and home décor. The intricate and beautiful designs created through crochet make it a beloved pastime for many people around the world. Whether you're a beginner or an experienced crafter, crochet offers a rewarding and enjoyable way to express your creativity and make unique, handmade items.

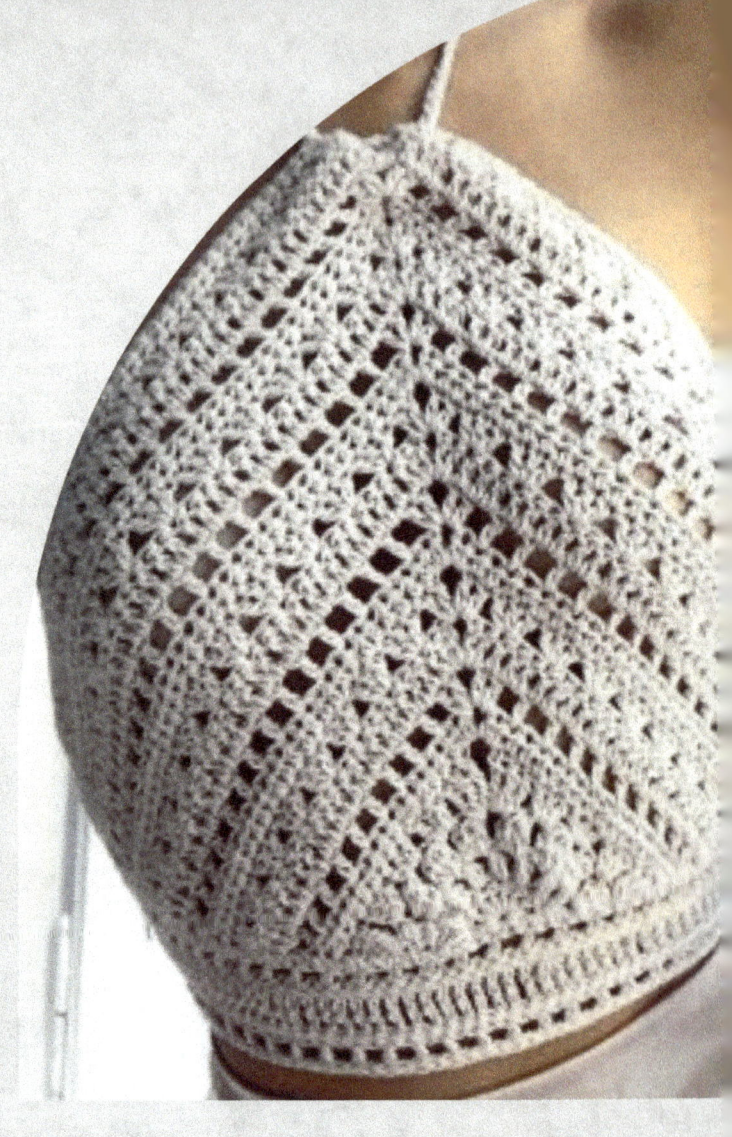

Basic Supplies

Yarn: Choose a yarn appropriate for your project. Yarn comes in different weights (thickness) and materials, like cotton, acrylic, wool, etc. Beginners often start with a medium-weight yarn (worsted weight) in a light color, as it's easier to see the stitches.

Crochet Hooks: Crochet hooks come in various sizes, indicated by a letter or number (e.g., 3.5mm, G, H, etc.). The size of the hook you use depends on the weight of your yarn and the tension you want. Many beginners start with a medium-sized hook, like an H/5.0mm hook.

Tapestry Needle: Used for weaving in ends and sewing pieces together.

Scissors: A good pair of scissors for cutting yarn.

Stitch Markers: These help mark your stitches or keep track of rounds in circular projects.

Measuring Tape: Useful for checking gauge and measuring your work.

Start with a simple project and gradually build your collection of tools and skills as you go. Happy crocheting!

STITCHES

Crochet has a variety of stitches, each serving a different purpose and creating unique textures and patterns. Here are some common ones

Crochet hook: The crochet hook is your tool on the path to greatness! Your pattern may refer to different parts of the crochet hook - here is an illustration to help you understand it all a little better.

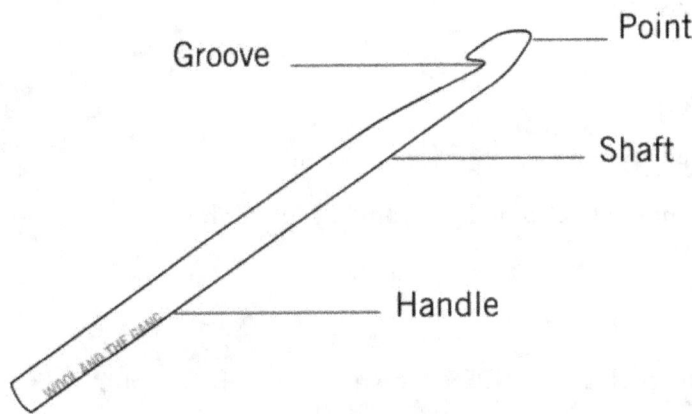

Turning Chains: When working in crochet, you often need to do a 'turning chain' at the beginning of your row. This creates a stitch that 'lifts' you up to the next level, so you're ready to crochet the next row. The turning chain is made up of chain stitches, and the number of stitches varies between different types of stitches. (Your pattern will tell you how many stitches to use for the stitch you're working in.)

Chain stitch

This is the foundation of most crochet work and can also be used as a technique on its own.

1. Make a slipknot and place it on the shaft of your crochet hook. Hold the hook in your right hand and the yarn in your left hand.

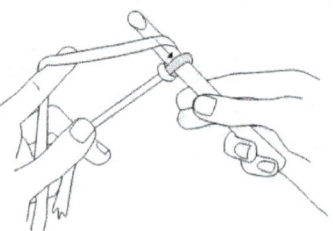

2. Move the point of the crochet hook UNDER the yarn from left to right, then move it OVER the yarn from right to left. The yarn is now looped around your crochet hook.

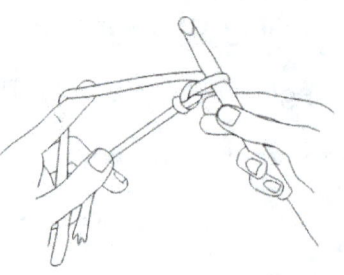

3. Scoop up the yarn with the groove of the hook, and pull it through the loop already on your hook. Slide the new stitch towards the shaft of the hook. You've now made one chain stitch.

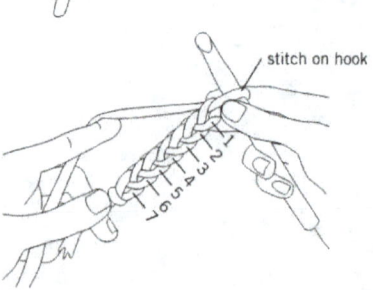

Repeat steps 2 and 3 to keep creating new stitches. Take care not to pull your stitches too tightly! When counting your stitches, count each of the loops except the one on your hook.

Single crochet

This stitch is one of the most basic crochet stitches. It uses a turning chain of 1 stitch. To work into a foundation chain at the beginning of your work, start with your hook in your right hand and the work in the left. Work across your foundation chain from right to left.

1. Insert your crochet hook into the middle of the second stitch from the hook (not counting the stitch on the hook!).

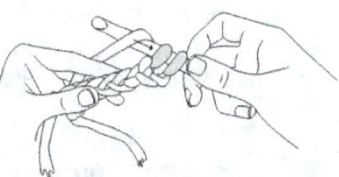

2. Move the hook under and then over the yarn. Scoop the yarn with the groove of your hook, and pull it through the stitch. There are now two loops on your hook.

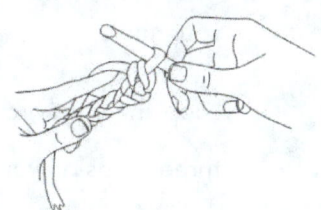

3. Loop the yarn around the hook again, and pull the yarn through BOTH of the loops on your hook. You have now worked one stitch in single crochet, and there's a single stitch on your hook again.

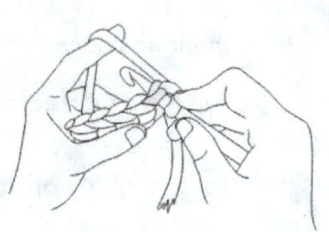

4. To continue working in single crochet, insert the hook into the next stitch of your row and repeat steps 2 and 3.
To work into a stitch that was crocheted on the previous row, insert your crochet hook underneath both strands of the sideways 'V' at the top of the next stitch, then repeat steps 2 and 3.

Double Crochet

This stitch is a taller version of the single crochet. It uses a turning chain of 3 stitches.

1. Make 3 chain stitches (this is your turning chain). Starting with the hook in front of the yarn, move the hook underneath the yarn, and then over it, so the yarn ends up looped around the shaft of the hook.

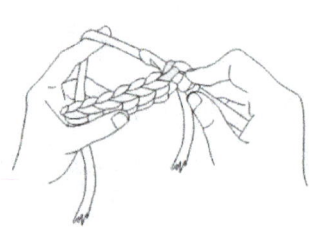

2. Insert the hook into the middle of the next stitch, underneath both strands of the sideways 'V' at the top.

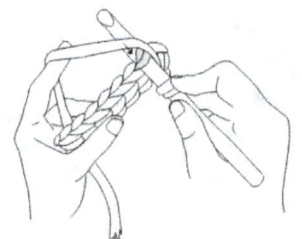

3. Loop the yarn around the groove of the hook, and pull it through the stitch and up onto the shaft of the hook. There are now three loops on your hook.

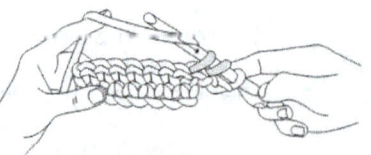

4. Loop the yarn around the hook again, pull the yarn through two of the three loops on your hook. You now have two loops left on your hook.

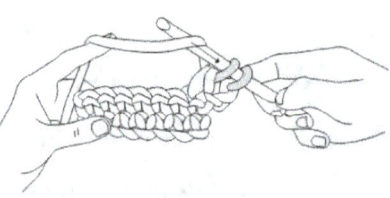

5. Loop the yarn around your hook once more and draw through BOTH of the loops on your hook. There is now a single loop left on your hook and you have worked one stitch in double crochet.

6. To continue working in double crochet, loop the yarn around the hook again, and repeat steps 2 to 5.

Half Double Crochet

Half double crochet is one of the basic crochet stitches that has a yarn over similar to double crochet and the width of that extra yarn over is what gives it a little bit of extra height and a third loop

1. Yarn over the hook and insert the hook into the work (third chain from the hook on the starting chain).

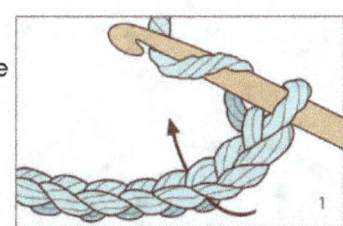

2. *Yarn over the hook and draw up a loop—three loops on the hook.

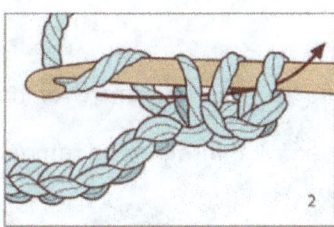

3. Yarn over the hook again and draw through all three loops on the hook—one half double crochet made.

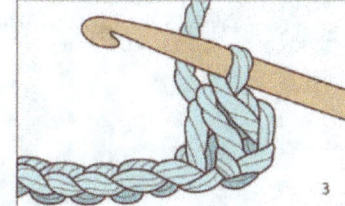

4. Yarn over the hook, insert the hook into the next stitch; repeat from * in step 2.

Treble Crochet

The treble crochet stitch produces a lovely tall stitch, which means your fabric works up quickly! It is also sometimes called triple crochet.

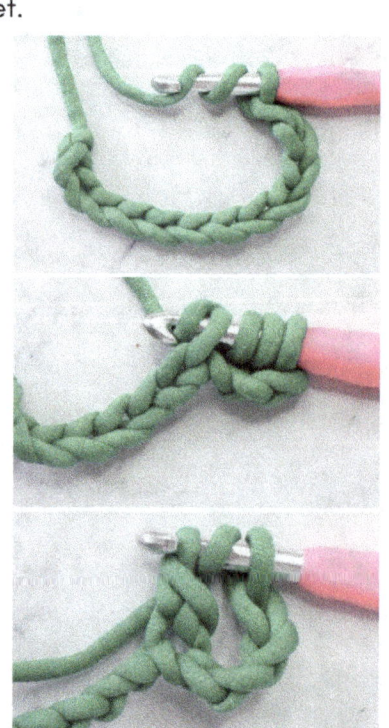

1. Yarn over hook twice, then insert hook into next stitch.

2. Yarn over hook and draw yarn through stitch - (there are four loops on the hook).

3. Loop yarn over hook and draw through two loops, (there are now three loops remaining on the hook).

4. Yarn over hook and draw through two loops.

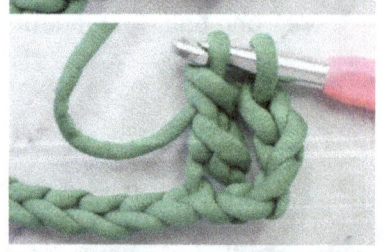

5. Again, loop yarn over hook and draw through the last two loops on the hook (there is now one loop remaining.)

Abbreviation

Following is a list of crochet abbreviations used in patterns by yarn industry designers and publishers. In addition, designers and publishers may use special abbreviations in a pattern, which you might not find on this list. Generally, a definition of special abbreviations is given at the beginning of a book or pattern. These definitions reflect U.S. crochet terminology.

Appreviation	Term	Description
*		Repeat the instructions after the single asterisk as many times as given.
Beg	beginning	Like at the beginning of the row/round.
Rep	Repeat	Instructs to repeat stitches or instructions, like from *to*.
tr2tog	Treble crochet two stitches together	Decrease 1 stitch by working two treble crochet stitches together.
dc	Double crochet	The double crochet is one of the basic crochet stitches.
dc2tog	Double crochet 2 together	Decrease 1 stitch by working two double crochet stitches together.
PM	Place marker	Instructs place a marker on a given stitch.
FDC	Foundation double crochet	The foundation double crochet is a variation of the regular double crochet used to start a crochet projects where you make the chains and double crochet stitches at the same time.
hdc	Half double crochet	The half double crochet is one of the basic crochet stitches.

Appreviation	Term	Description
inc	Increase	Increase the number of stitches you have
incl	Including / Include	To include something in the project, like including a specific stitch in a repeat.
mr	Magic ring	A double crochet worked around the back post of the stitch on the previous row.
RS	Right side	Tells you that this is the front of your crochet pattern.
sc	Single crochet	The single crochet is one of the basic crochet stitches.
sk	Skip(ped)	Skip a given number of stitches before you continue crocheting in the next one.
sl st	Slip stitch	The slip stitch is one of the basic crochet stitches.
st or sts	Stitch(es)	Refers to a stitch or stitches.
WS	Wrong side	This tells you that this is the back of your crochet pattern.

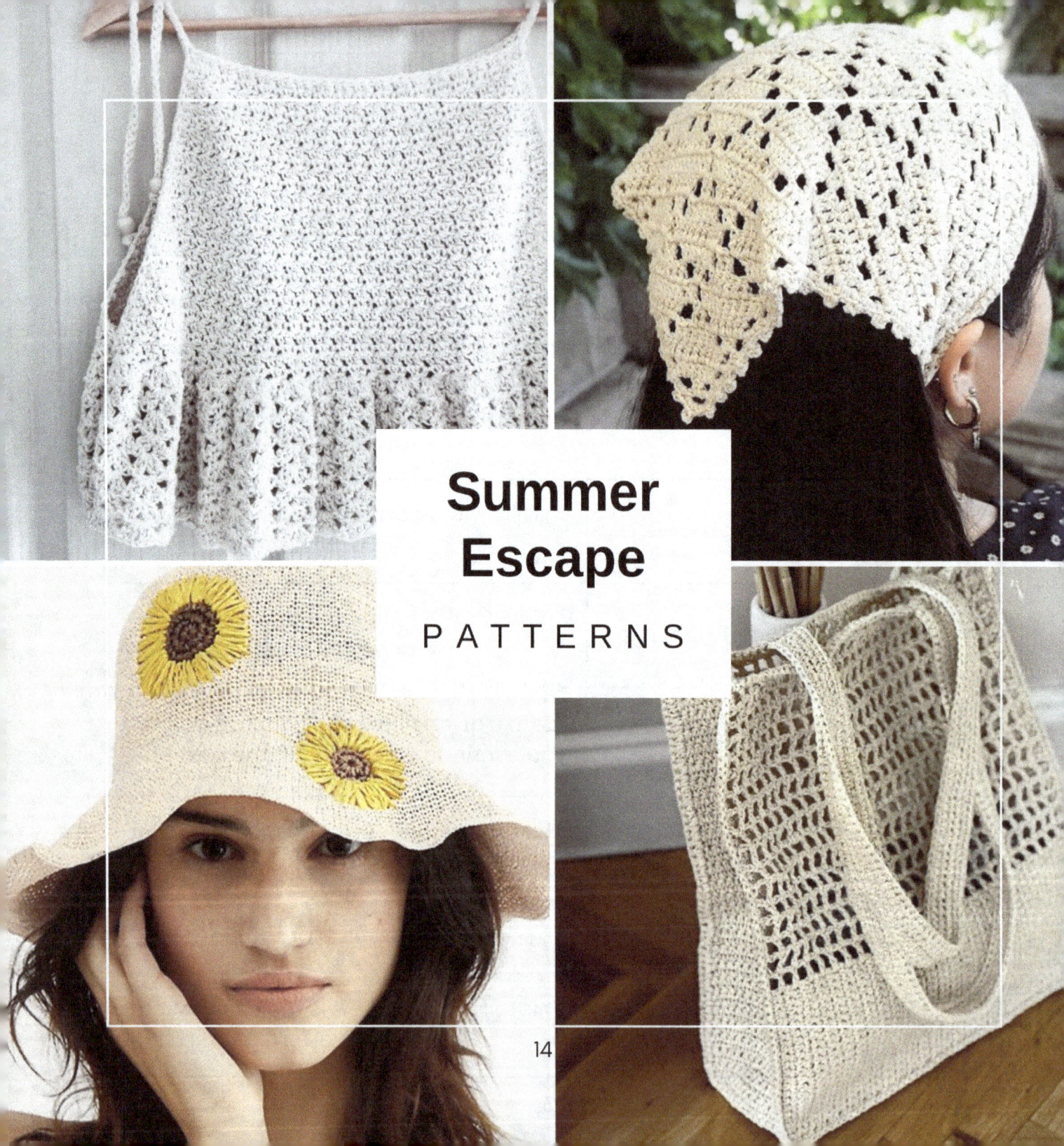

Summer Escape
PATTERNS

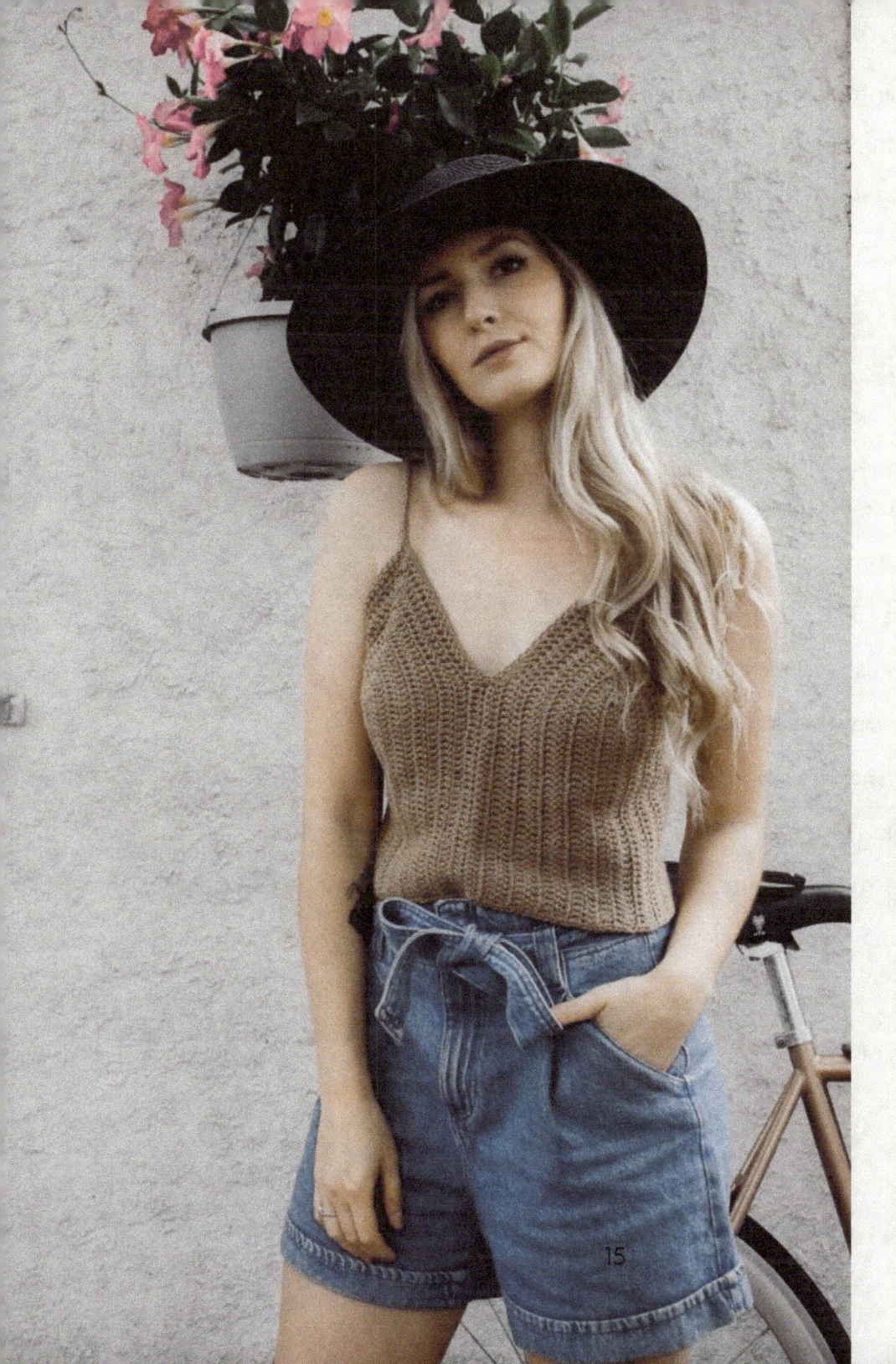

Chasing Summer Tank Top

The Chasing summer tank top is an extremely easy-to-crochet summer tank top with thin straps and vertical stitching. The stand-out feature of this piece is the thoughtful shaping around the chest which provides an incredible fit on any size.

Materials

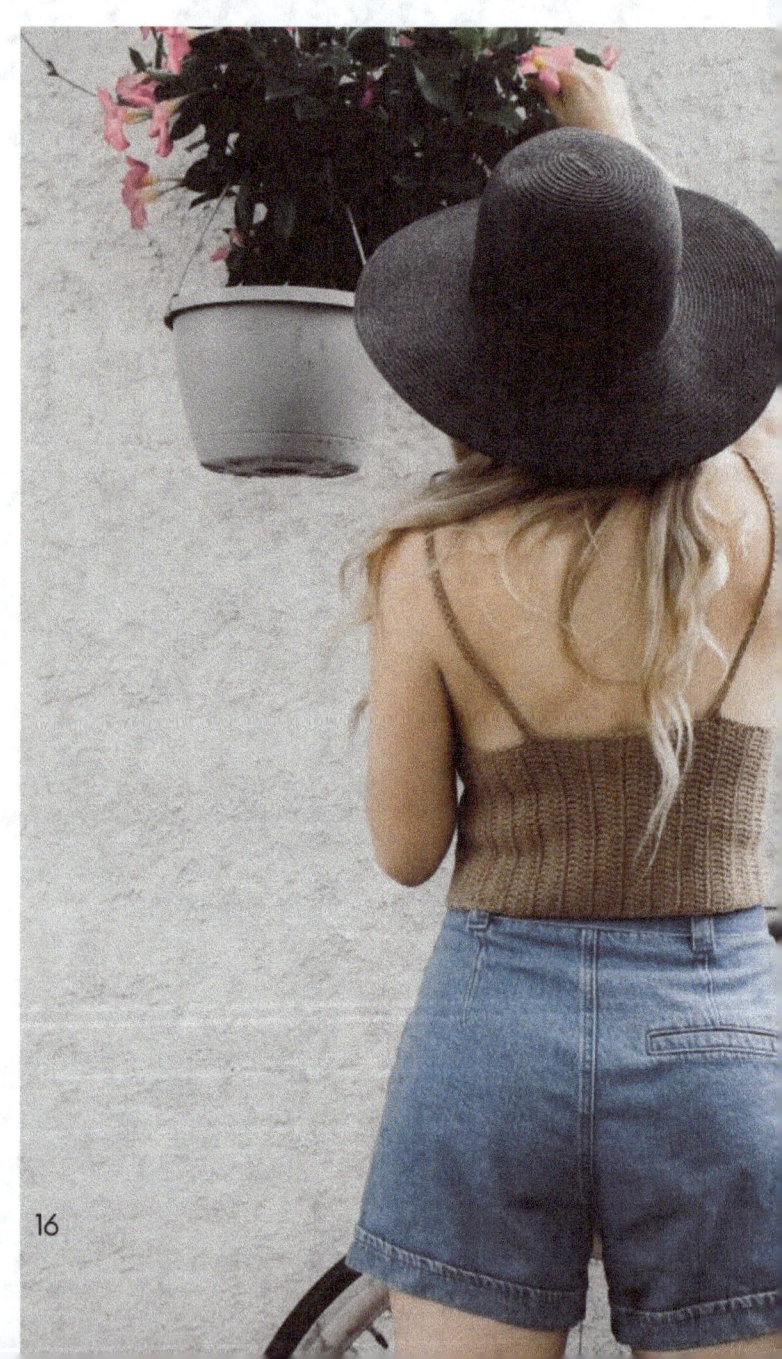

Yarn: DK-WeCrochet CotLin in Cashew

70% Tanguis Cotton, 30% Linen

123 yds [112 m] per 1.76-oz [50 g] skein

Yarn Substitution Notes: Substitute WeCrochet CotLin with any similar, DK weight yarn. Most fibers should work fine in place of CotLin, but for similar results to the sample shown, choose a cotton yarn.

Hook: Size U.S. E/4 (3.5 mm) or size needed to obtain gauge

Notions: Tapestry needle, several locking stitch markers

Measurements

	A	B	C	D	E
	FINISHED BUST *Circumference*	BACK LENGTH	INDIVIDUAL FRONT PANEL WIDTH	TOTAL FRONT PANEL WIDTH *Measured across both front panels*	BACK PANEL WIDTH
XS	28" / 71 cm	7" / 18 cm	6.5" / 17 cm	13" / 33 cm	14.5" / 37 cm
S	32" / 81 cm	7.5" / 19 cm	7.5" / 19 cm	15" / 38 cm	17" / 43 cm
M	36" / 91 cm	7.5" / 19 cm	8.5" / 22 cm	17" / 43 cm	19" / 48 cm
L	40" / 102 cm	7.75" / 20 cm	9.25" / 23 cm	18.5" / 47 cm	21.5" / 55 cm
XL	44" / 112 cm	8.25" / 21 cm	9.25" / 23 cm	18.5" / 47 cm	25.5" / 65 cm
2X	48" / 122 cm	8.5" / 22 cm	10.25" / 26 cm	20.5" / 52 cm	27.5" / 70 cm
3X	52" / 132 cm	9" / 23 cm	11" / 28 cm	22" / 56 cm	30" / 76 cm
4X	56" / 142 cm	10" / 25 cm	12" / 30 cm	24" / 61 cm	32" / 81 cm
5X	60" / 152 cm	10.25" / 26 cm	13" / 33 cm	26" / 66 cm	34" / 86 cm

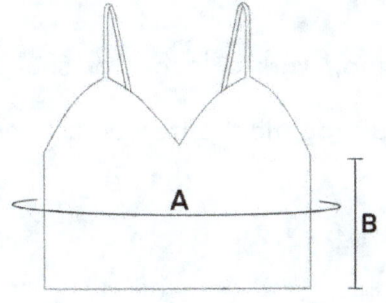
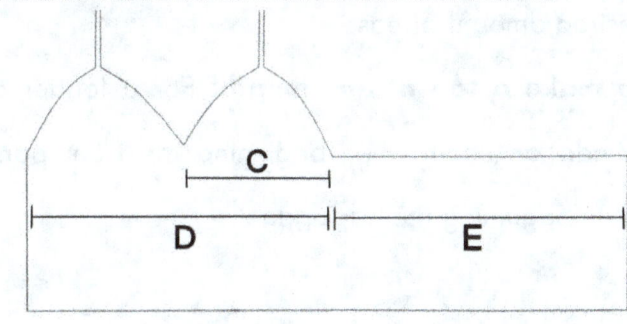

Pattern Notes

Sizing: This tank top is written in nine sizes as follows: XS (S, M, L, XL) (2X, 3X, 4X, 5X). Make sure to follow the numbers for your size only.

Stitch Counts: Stitch counts are listed after each row. If no stitch count is given, there has been no change since the previous row. If only one number is provided, it applies to all sizes.

Reversible: There is no right side or wrong side; both sides are identical. You choose which side to wear as the "right side."

Seaming: When seaming your garment, make sure to keep all seams loose and do not pull tight in order to maintain some stretch, otherwise this seam will pucker during wear.

Turning Chain: The turning does not count as a stitch.

Construction: The front of this top is worked in two identical pieces that get seamed together along the center-front. After seaming these pieces together, the back panel is worked directly onto your front piece until reaching your desired circumference. You can follow the number of rows as instructed on the back piece to achieve the dimensions in the chart, or you can work fewer (or more) rows along the back in order to achieve your desired amount of ease.

To make a top of any length: For a longer or shorter top, work a longer or shorter foundation chain when beginning the front panels. Work an identical stitch adjustment when beginning the back panel.

Pattern

FRONT PANEL (Make 2)

Leaving a long tail for seaming, FDC 34 (36, 36, 38, 40) (42, 44, 48, 50). For a longer (or shorter) tank top than sample shown, work a longer (or shorter) chain here.

Row 1 (Set-Up Row): Ch 2, dc in each st to end of row, work 5 dc in end of last st (see picture), PM in 3rd dc of this 5-dc cluster, continue working in the same direction down your foundation chain, work 34 (36, 36, 38, 40) (42, 44, 48, 50) dc to end of row, turn. [73 (77, 77, 81, 85) (89, 93, 101, 105) dc]

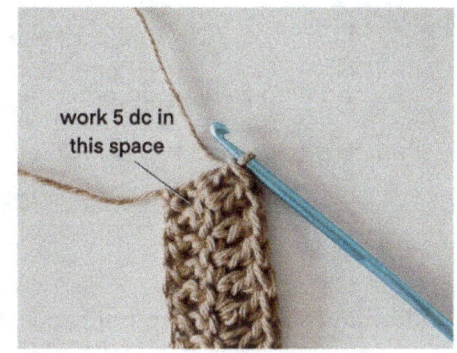
work 5 dc in this space

Row 2: Ch 2, dc in each st to marked st, work 5 dc in marked st, PM in 3rd dc of this 5-dc cluster, continue dc in each st to end of row. [77 (81, 81, 85, 89) (93, 97, 105, 109) dc]

Rep last row 5 (6, 7, 8, 8) (9, 10, 11, 12) more times, or until your piece measures approximately 6.5 (7.5, 8.5, 9.5, 9.5) (10.25, 11, 12, 13)" [16.5 (19, 21.5, 24, 24) (26, 28, 30.5, 33) cm] in width.

Each Row 2 rep increases your stitch count by 4.

You should finish with 97 (105, 109, 117, 121) (129, 137, 149, 157) dc in your final row, unless you adjusted the number of Row 2 reps.

Fasten off, leaving long tail for seaming.

Rep all instructions for an identical panel, but do not fasten off after completing your second panel. Place a stitch marker in this active loop and proceed to Seaming Your Front Panels Together. You will come back to this loop to work the Back Panel.

Seaming Your Front Panels Together

- Lay both of your panels flat with the same side facing you and the long tail you left after finishing the first panel in the center. You will use this tail to seam your pieces together.
- With a tapestry needle and your long tail, seam your panels together using the whip stitch or seaming method of your choice. Stop at approximately 1 (1.5, 1.5, 1.5, 2) (2, 2.5, 2.5, 3)" [2.5 (4, 4, 4, 5) (5, 6, 6, 8) cm] past the length of your initial foundation chain. The height at which you stop seaming is what determines your neckline depth. Do not weave in this end yet, you will come back to it once your top is seamed together in case you need to make any adjustments to this neckline.

BACK PANEL

Return to the live loop from your second front panel and insert your hook to continue crocheting.

Row 1: Ch 2, dc in next 33 (35, 35, 37, 39) (41, 43, 47, 49) sts, dc2tog, turn. [34 (36, 36, 38, 40) (42, 44, 48, 50) dc]

Note: If you adjusted your front panel foundation chain, adjust this number of back panel stitches by the same amount. For example, if you worked 10 additional foundation double crochets, add 10 double crochets to this Row 1 stitch count.

Row 2: Ch 2, sk first dc, dc in each st to end of row, turn [33 (35, 35, 37, 39) (41, 43, 47, 49) dc]

Row 3: Ch 2, dc in each st to end of row, turn.

Rep Row 3 until you have worked a total of 32 (37, 42, 47, 56) (61, 66, 71, 76) rows across your back panel.

Next Row (S, L, 2X, 4X): Ch 2, dc in each st to last st, work 2 dc in last st.

Next Row (XS, M, XL, 3X, 5X): Ch 2, work 2 dc in first st, dc in each st to end of row.

Your back panel width should measure approximately 14.5 (17, 19, 21.5, 25.5) (27.5, 30, 32, 34)" [37 (43, 48, 55, 65) (70, 76, 81, 86) cm].

Fasten off, leaving long tail for seaming panels together.

Seaming Your Tank Top

Optional: To double-check your fit before seaming, you can pin your top into a tube with locking stitch markers and try it on. Bring the last back panel row together with your front panel. Pin these stitches together lengthwise. Try on your top before seaming it closed and adjust the number of rows on your back panel if needed. For a tighter top, rip out a few rows; if your top is too tight, work additional Row 2 reps until reaching your desired circumference.

With a tapestry needle use your long tail to seam your panels together into a tube using the whip stitch or seaming method of your choice. Weave in ends.

Bottom Finishing Row

Next, you will work a row of single crochet along the bottom edge for a neater finish.

Join yarn somewhere on the side of your tank top to the bottom edge with a sl st, ch 1, work 2 sc for every dc row-end until reaching your starting point, sl st into first sc to join, fasten off, weave in ends.

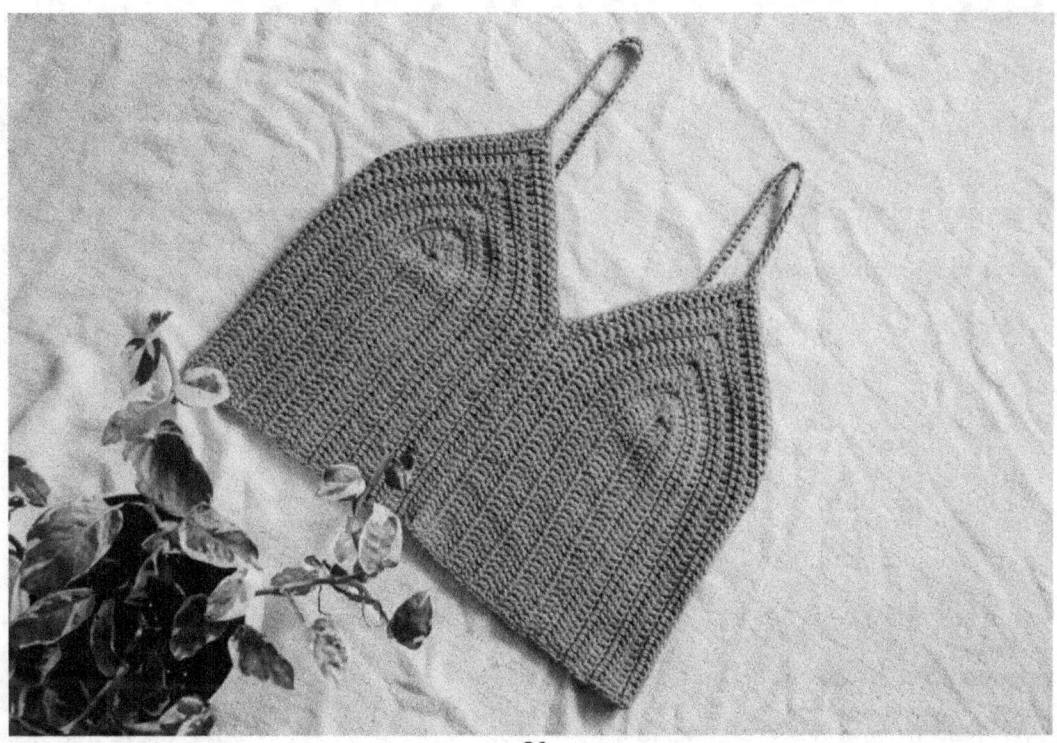

STRAPS

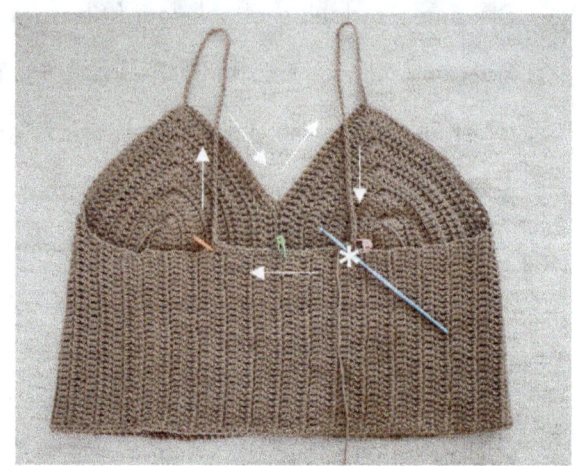

- Choose which side you'd like to wear as the front and lay your top so that this Right Side is facing down, and the back of your top is toward you.
- To create your straps, you will join new yarn to the marked stitch on the right (see the asterisk), single crochet across the back to your second strap marker, work your strap chain, single crochet into to the center stitch of the corresponding front panel to connect the strap, work down the neckline to the center-front, work up the neckline to the center stitch of the other front panel, work a chain that is equal in length to your first chain, and then single crochet into the first stitch of the row - the marked stitch that you started with (at the asterisk).

- Place a stitch marker into the top edge of your Back Panel to mark the true center-back. Being mindful of this center point, place two additional markers on either side of the center marker at equal distances apart to mark out where you would like your straps to be.

- You can remove your center marker now. Join new yarn to the right-most marker with a sl st. Ch 1, sc across to opposite marker by working approximately 2 sc into each dc row-end.

- For longer (or shorter) straps, work a longer (or shorter) chain than instructed below.

- Ch 50, sc into the center marked st on your front panel to join your strap to the front, sc in each dc, working toward the center-front of your top, continue to sc into each dc until reaching the center marked st on your other front panel, sc into this marked st, ch 50, sc into the marked st that you started with. You should be at your starting point. Sl st into your first sc to join.

- Before fastening off, try on your top to make sure you are happy with the strap length. Adjust if necessary. Once satisfied with strap length, fasten off. At this point, you can also adjust your center-front seam to your desired height, now that you can see how the tank top lays on your body. Weave in ends.

Strap Finishing Rows

Next, you will work a row of sc along the straps and the raw edges at the underarm for a neater finish. Lay your tank top in the same orientation as you did when working the straps, with your Right Side facing down, and the back of your top toward you (as shown in the photos below).

First Side

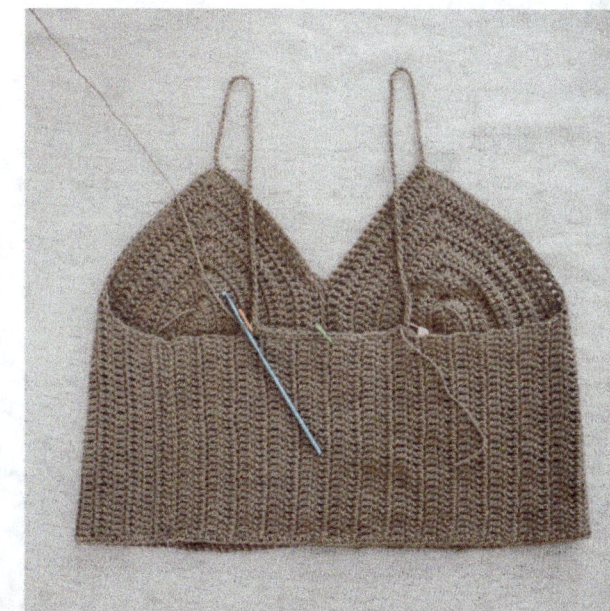

Join new yarn to the left of the strap on your left with a sl st. Sc into each st along the back working 2 sc for every dc row-end, continue to sc into each dc from your front panel until reaching the strap. Sc into the back-bumps of each ch until reaching your starting point, sl st into first sc to join, fasten off, weave in ends.

Second Side

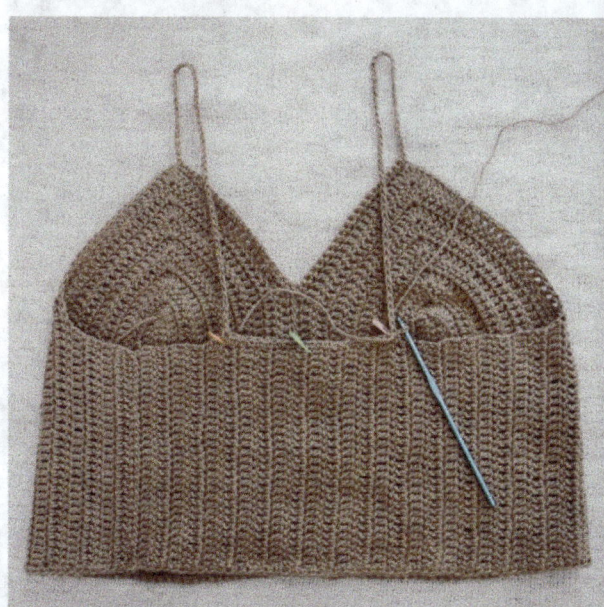

Join new yarn to the right of the strap on your right with a sl st. Sc into the back-bumps of each ch, sc into each dc along the front panel until reaching the dc row-ends from the back panel, work 2 sc for every dc row-end until reaching your starting point, sl st into first sc to join, fasten off, weave in ends.

Weave in any remaining ends, block to dimensions in chart.

Granny Squares Vest

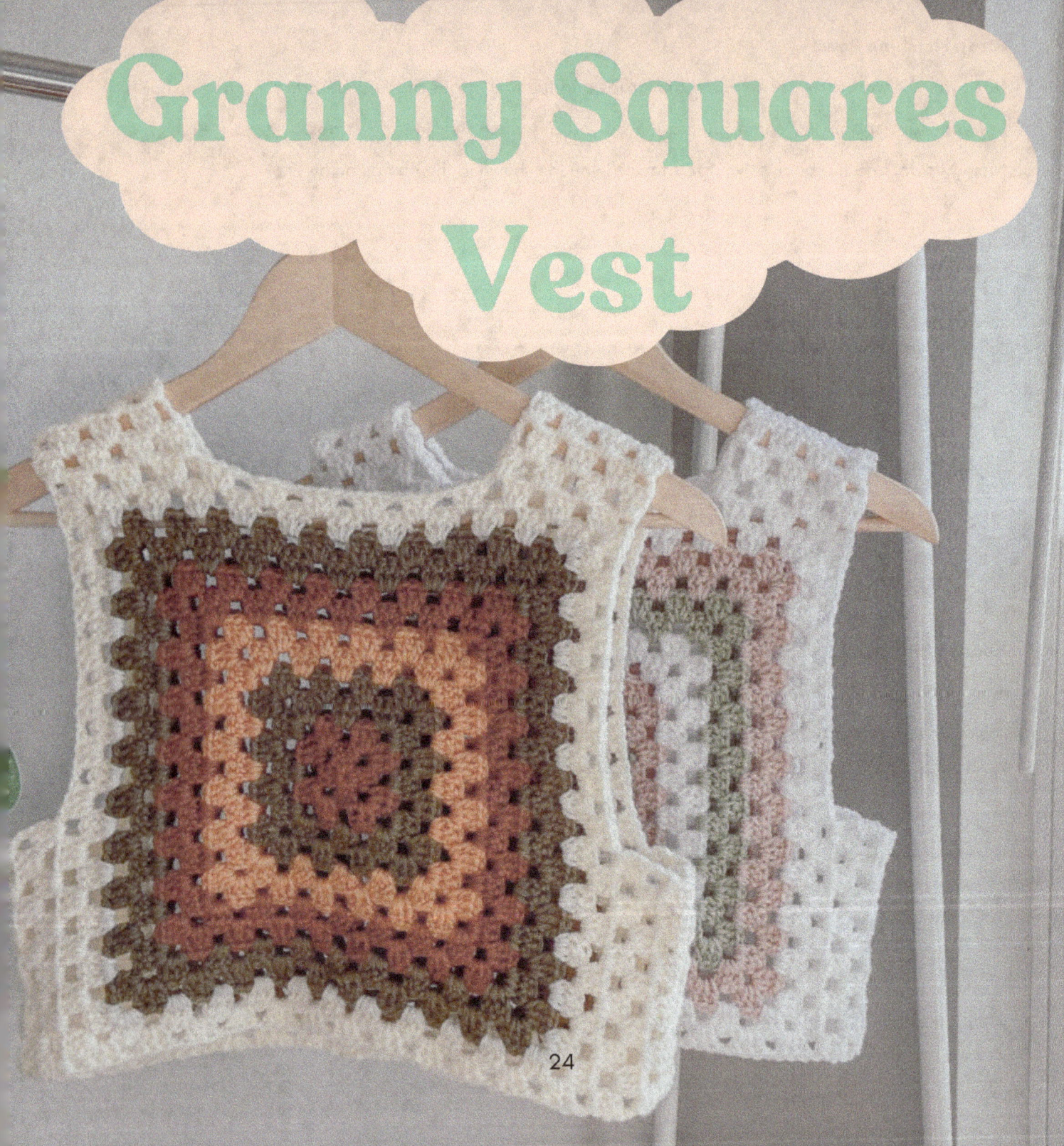

Materials & Measurement

YARN: Medium Weight (4) – ANY brand will do! I mixed different brands together of left over yarn I had lying around because I wanted to be a bit more conscious with this project.

Crochet Hook – 5.00mm

Others:

- Scissors
- Darning Needles
- Stitch Markers

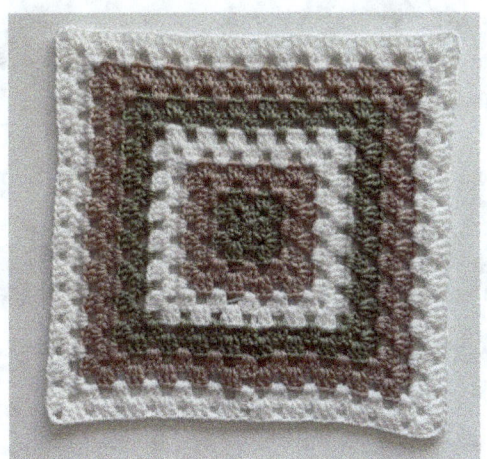

Size	Square's Measurement
XS	12
S	13
M	14
L	15
XL	16
2XL	17

This vest is so easily customizable. These are just size guidelines, but you can simply make it the size you need to for YOU and I will show you how here in this pattern

Pattern

Pattern Notes

- Turning Ch 3 DOES count as a dc stitch in this pattern.
- When making granny squares, you work in ch spaces and not in sts (unless otherwise directed to).

Square Panel

Start off by making a magic ring.

Round 1: Ch 3, (first ch 3 of EVERY ROUND counts as a dc st), work 2 dc into the magic ring, ch 3, work 3 dc into the magic ring, ch 3, work 3 dc into the magic ring, ch 3, work 3 dc into the magic ring, ch 3. Sl st into the first st of the round and turn your work.

Round 2: Ch 3, work 2 dc into ch space, ch 3, work 3 more dc in same ch space, ch 1, work 3 dc into next ch space, ch 3, work 3 more dc into same ch space, ch 1, work 3 dc into next ch space, ch 3, work 3 more dc into same ch space, ch 1, work 3 dc into next ch space, ch 3, work 3 more dc into same ch space, ch 1, sl st into the first st of the round BUT (if changing colors) pull through new yarn color and turn your work.

I changed colors every 2 rows, but you can change colors whenever you like, every 3 rows, 4 rows or no rows! Whatever floats your boat.

Round 3: (With your new added yarn color) Ch 3, work 2 dc in the ch 1 space, ch 1, *work 3 dc into the ch 3 space, ch 3, work 3 dc into the same ch 3 space, ch 1, work 3 dc into the next ch 1 space, ch 1, work 3 dc into the next ch 3 space, ch 3, work 3 dc into the same ch 3 space, ch 1, *repeat until the end of the round. Sl st into the first st of the round and turn your work.

Round 4-12 (4-10 for XS, 4-14 for M, 4-16 for L, 4-18 for XL, 4-20 for 2XL): Repeat the process of a dc cluster in each ch 1 space, with a ch 1 to separate each cluster and 2 dc clusters in each ch 3 space (the corner ch space), with a ch 3 to separate the 2 clusters.

Fasten off.

Straps

Attach Yarn to one of the 4 corners of your square.

Row 1: Ch 3, work 2 dc into the first ch space, work 1 dc cluster into the next 3 ch spaces (next 2 for XS, next 4 for M, next 5 for L, next 6 for XL, next 7 for 2XL, next 8 for 3XL, next 9 for 4XL, next 10 for 5XL), turn your work.

Row 2: Ch 3, work 1 dc cluster into the next 3 ch spaces (next 2 for XS, next 4 for M, next 5 for L, next 6 for XL, next 7 for 2XL, next 8 for 3XL, next 9 for 4XL, next 10 for 5XL), work 1 dc into the last st (the ch 3 from the previous round), turn your work.

Repeat rows 1-2 as many times as you need for your size.

Fasten off at 3 rows for XS, S and M

Fasten off at 4 rows for L, XL and 2XL

If you feel that the straps need longer or shorter for your size, feel free to add or take away rows as you want!

Repeat for other strap.

Sides of Vest

Attach yarn to one of the side corners of your square.

Row 1: Ch 3, work 2 dc into the first ch space, work 1 dc cluster into the next 5 ch spaces (next 4 for XS, next 6 for M, next 7 for L, next 8 for XL, next 9 for 2XL, next 10 for 3XL, next 11 for 4XL, next 12 for 5XL), turn your work.

Row 2: Ch 3, work 1 dc cluster into the next 5 ch spaces (next 4 for XS, next 6 for M, next 7 for L, next 8 for XL, next 9 for 2XL, next 10 for 3XL, next 11 for 4XL, next 12 for 5XL), work 1 dc into the last st (the ch 3 from the previous round), turn your work.

Repeat rows 1-2 as many times as you need for your size

Fasten off at 3 rows for XS, S and M

Fasten off at 4 rows for L, XL and 2XL

If you feel that the sides of your vest need to be wider or more narrow for your size, feel free to add or remove rows as you want!

Repeat for other side of the vest.

Repeat entire process for the back panel. When both panels are done, sew both panels together, weave in your ends, and...YOU'RE DONE!

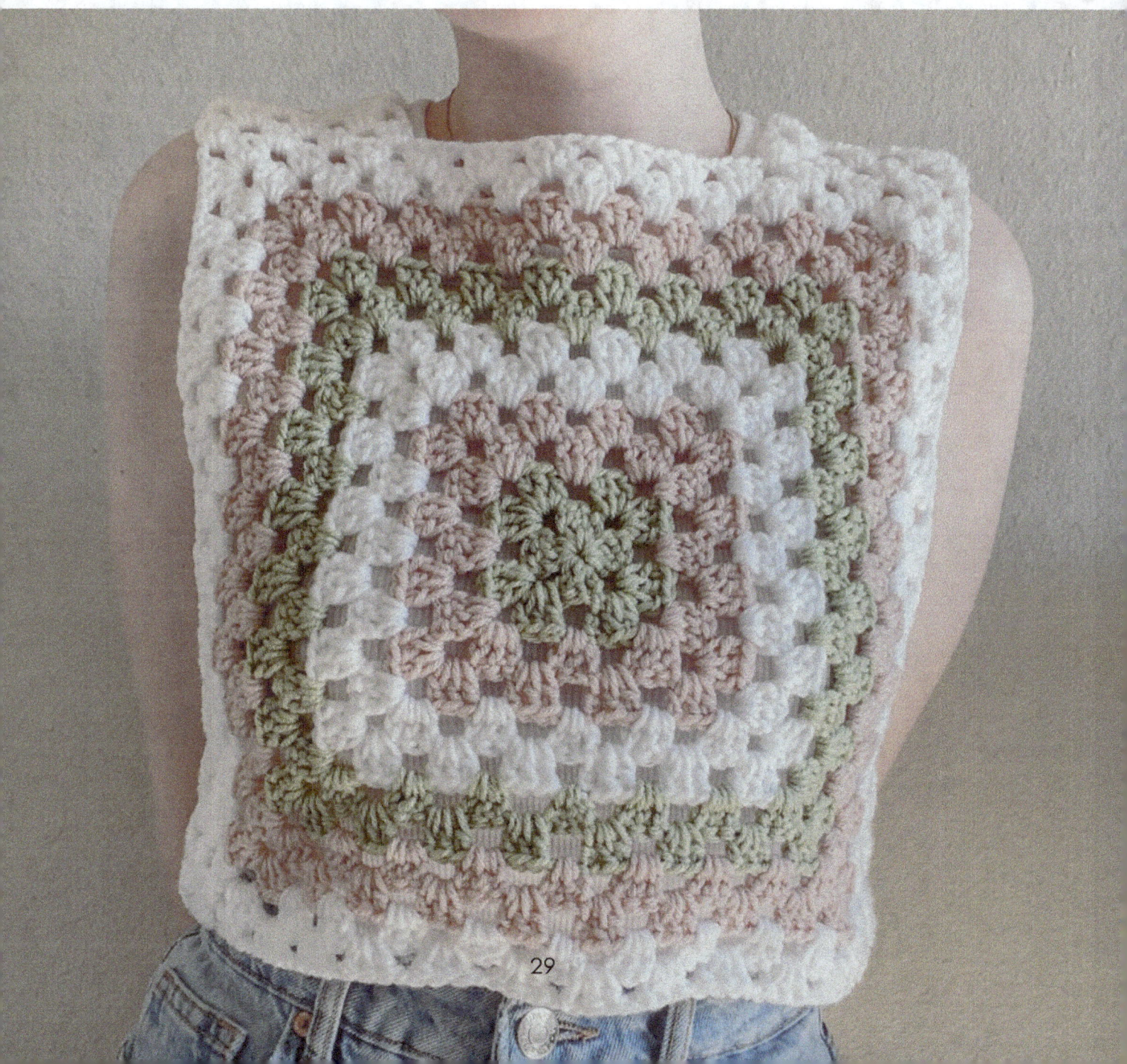

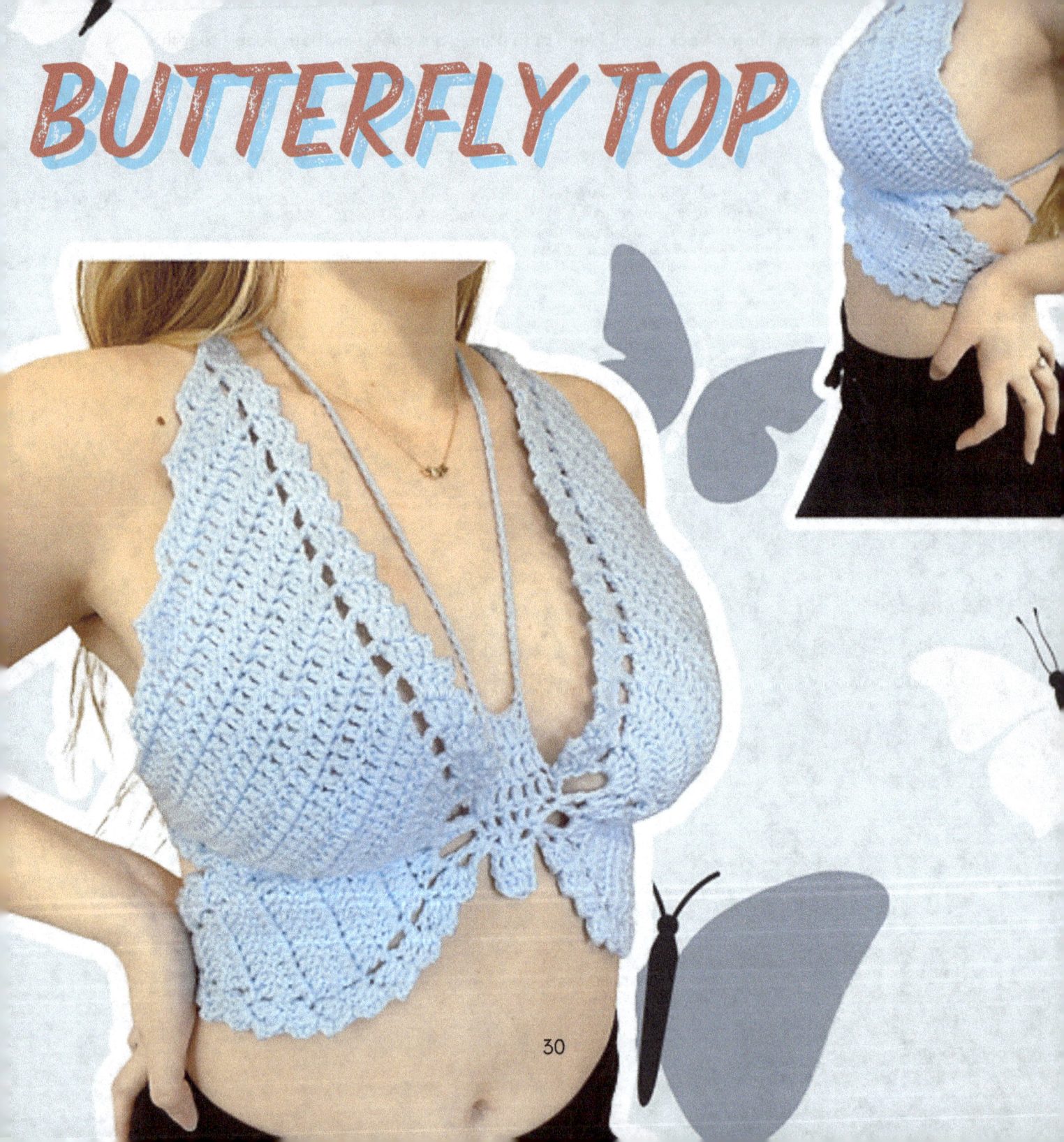

Materials

- **Yarn:** Weight 4 Cotton Yarn – Any color and texture you love I recommend Lion Brand Pima Cotton yarn.
- **Hook:** Size F/3.75mm
- Scissors
- Stitch markers

Measurements

Measurements	XS	S	M	L	XL
Upper wing coverage width	5.5"	6.5"	7.5"	8.5"	9.5"
Upper wing coverage height	5"	5.5"	6.25"	7"	7.5"

Pattern Notes

- This pattern is first worked from the middle of the top (the body of the butterfly), then the wings of the butterfly are added to the body by joining to the sides of the butterfly's body.
- The () at the end of each row depicts the total amount of double crochet stitches you should have at the end of each row.
- The turning ch's do not count as a stitch.
- When you see "Row # - #", that means you will repeat the instructions throughout the rows specified.

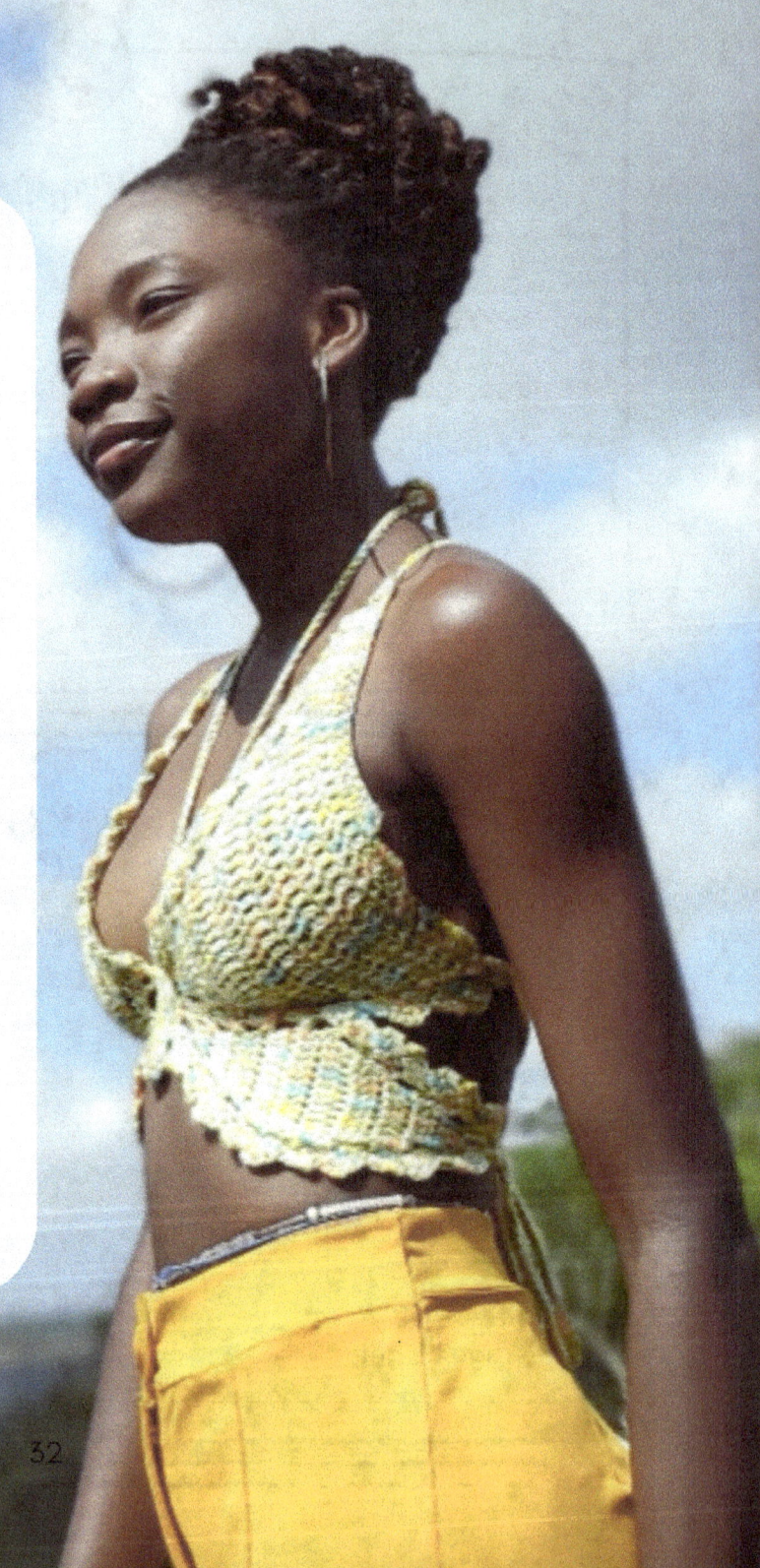

Pattern

Butterfly Body (Middle of Top)

Row 1: Ch 4. Place 4 dc in the 1st ch that you made. (4)

Row 2 - 3: Ch 3, turn. Dc across. (4)

Row 4: Ch 3, turn. Inc, dc across until one sts is left, inc. (6)

Row 5: Repeat row 4. (8)

Row 6: Turn. Slst into the 2nd st from your hook. Ch 3, dc in the same st as your ch 3, dc across until one st remains. Leave that st unworked. (6)

Row 7: Ch 3, turn. Dc across. (6)

Neck Straps

Ch 100. (This will be half of the neck strap. You can increase the st count if needed.)

Turn. [Starting in the 2nd ch from the hook, slst down the ch.]

Once you meet the top of the butterfly's body, slst across to the first st from row 7.

Ch 100 (or the same ch amount you did for the first strap). Repeat from [to] until you meet back onto the body.

Slst into the body.

Fasten off.

Butterfly Wings (x2)

Attach your yarn to the top of the 5th row of the butterfly body to the st we slst over that has no dc.

Row 1: We're now going to set up our wings. Ch 5. Dc in the same st the yarn was attached. Ch 5, dc between body rows 4 & 5. Ch 2, dc in the same st. Ch 3, dc between body rows 3 & 4. Ch 2, dc in the same st.

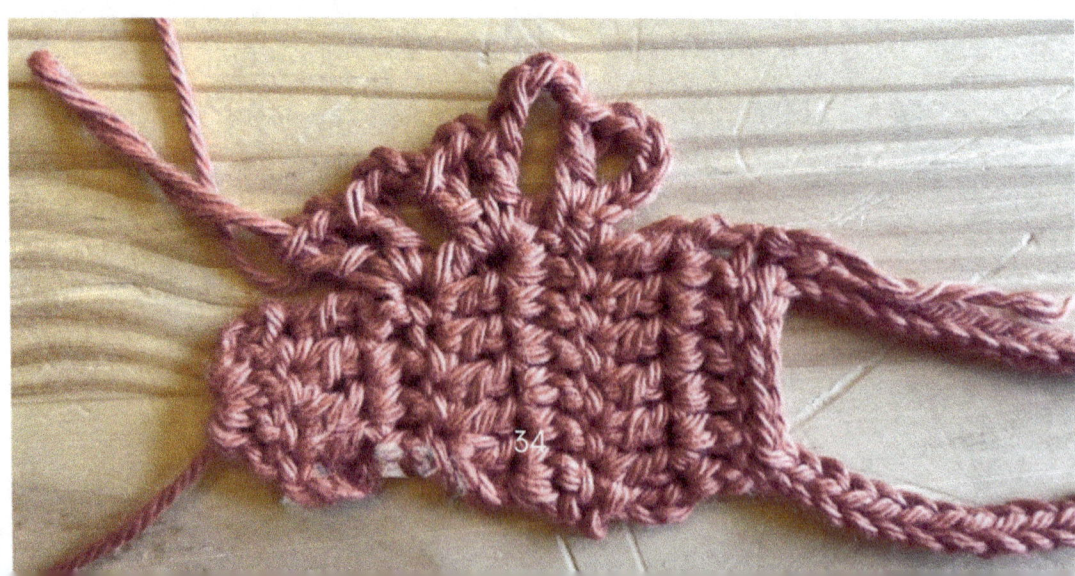

Row 2: Ch 3, turn. Place 4 dc in the first ch space, ch 1. [Place 3 dc in the next ch space, ch 1] repeat from [to] 1 more time. Place 5 dc in the next ch space, ch 1. Place 3 dc in the last ch space. Lastly, place 1 more dc at the top of the ch 3 at the end of the row (part of the ch 5 of the previous row). (19)

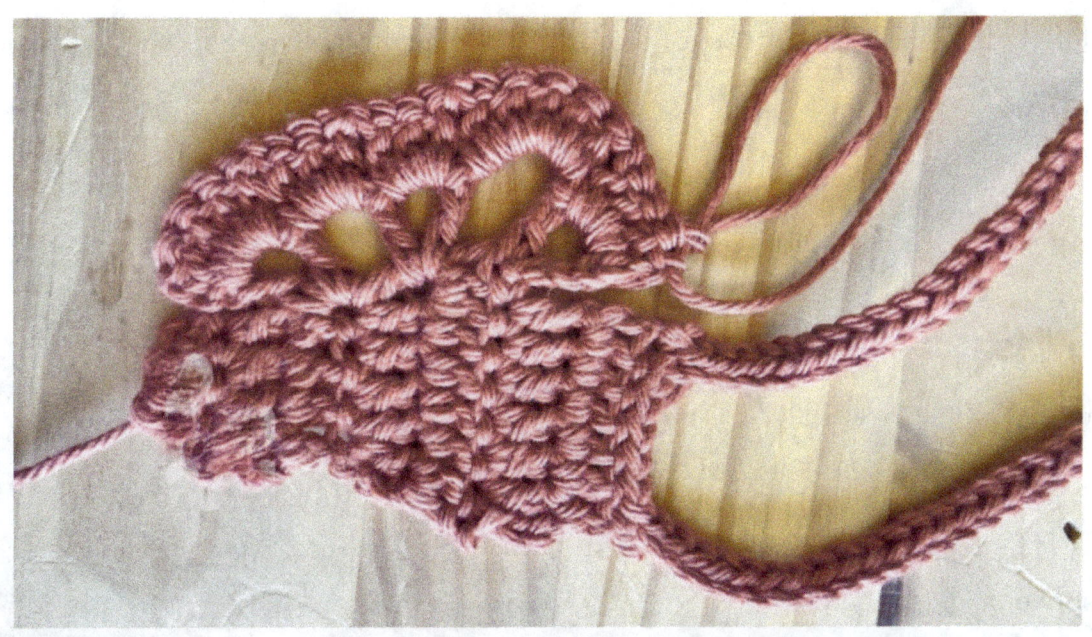

Row 3: Turn. Slst in the 2nd st, slst in the 3rd st. Ch 3, inc two times - once in the st the ch 3 is, and once in the next st. (4). Ch 2, sk the ch space, inc in the next 5 sts (10). Ch 2, sk ch space, place 3 dc in the middle st of the next three sts (3). Ch 2, sk ch space, inc in the next 3 sts (6). Ch 2, sk ch space, inc in the next 2 sts, leaving the last two sts unworked (4). (27)

Row 4: Turn. Slst in the 2nd st, slst in the 3rd st. Ch 3, inc two times (4). Ch 2, sk ch space, [inc, dc] repeat from [to] 2 more times (9). Ch 2, sk ch space, place 3 dc in the middle st of the next three sts (3). Ch 2, sk ch space, repeat from [to] 5 times (15). Ch 2, inc in the next 2 sts, leaving the last two unworked (4). (35)

Only sizes S - XL:

Row 5 - (6, 6, 8, 8): Turn. Slst in the 2nd st, slst in the 3rd st. Ch 3, inc two times (4). Ch 2, sk ch space, inc in the first st, dc across until one st left before the next ch space, inc. Ch 2, sk ch space, place 3 dc in the middle st of the next three sts (3). Ch 2, sk ch space, inc, dc across until one st left before the next ch space, inc. Ch 2, inc in the next 2 sts, leaving the last two unworked (4).

Upper Wing

Row 5 (7, 7, 9, 9) Turn. Slst in the 2nd st, slst in the 3rd st. Ch 3, inc two times (4). Ch 2, sk ch space, inc, dc across until one st left before the next ch space, inc. Ch 2, sk ch space, place 3 dc in the first st, leaving the rest of the sts unworked (3). (24 (28, 28, 32, 32) (36, 40, 40, 44))

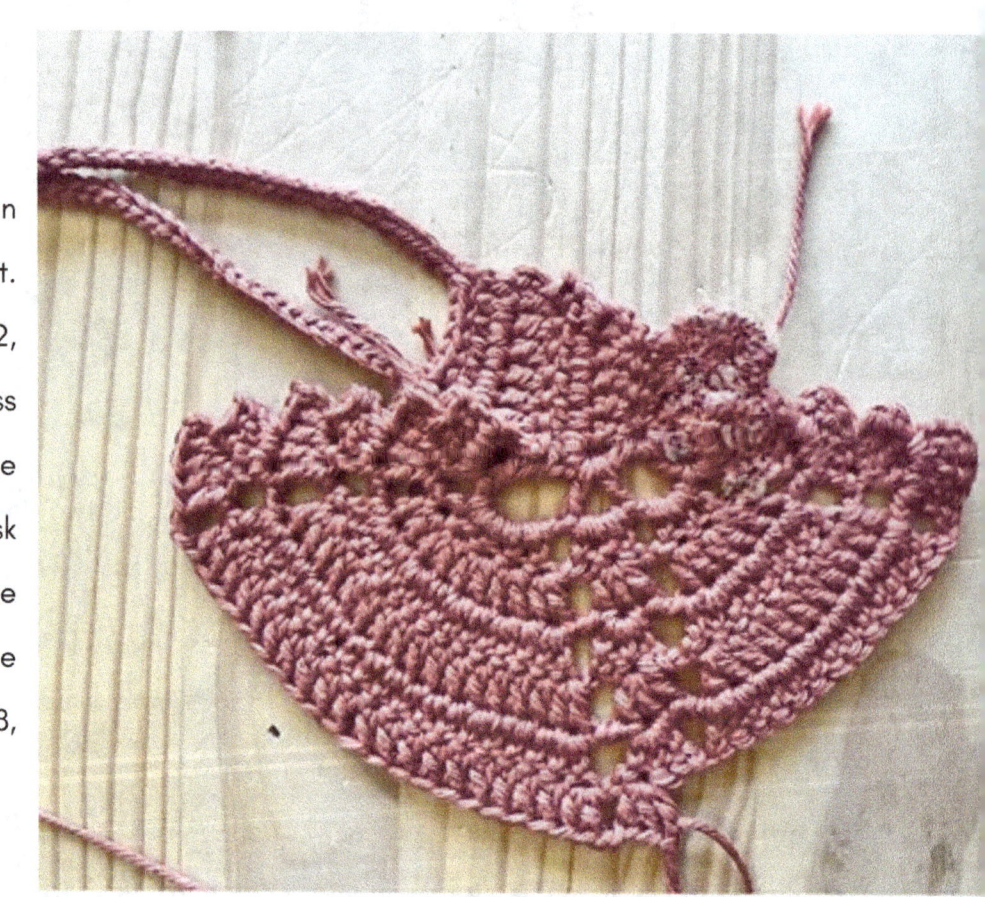

Row 6 (8, 8, 10, 10): Turn. Slst in the 2nd st. Ch 3, inc two times (4). Ch 2, sk ch space, inc, dc across until one st left before the next ch space, inc. Ch 2, sk ch space, inc in the next 2 sts (4). (27 (31, 31, 35, 35) (39, 43, 43, 47))

Now, we will only increase once in the middle, not two times.

Row 7 (9, 9, 11, 11): Turn. Slst in the 2nd st, slst in the 3rd st. Ch 3, inc two times (4). Ch 2, sk ch space, inc, dc across until the next ch space. Ch 2, sk ch space, inc in the next 2 sts (4).

Row 8 (10, 10, 12, 12): Turn. Slst in the 2nd st, slst in the 3rd st. Ch 3, inc two times (4). Ch 2, sk ch space, dc across until one st left before the next ch space, inc. Ch 2, sk ch space, inc in the next 2 sts (4).

Continue alternating between the last two rows until you have a total of 9 (11, 13, 15, 17) (21, 23, 25, 27) rows and 30 (34, 36, 40, 42) sts.

Row 10 (12, 14, 16, 18): Turn. Slst across 3 times starting in the 2nd st, slst in the next ch space, slst 2 more times. You should be in the second st after the first ch space. Ch 3, dc across until one st left before the next ch space, inc. Ch 2, sk ch space, inc in the next 2 sts (4). (26 (30, 32, 36, 38))

Row 11 (13, 15, 17, 19): Turn. Slst in the 2nd st, slst in the 3rd st. Ch 3, inc two times (4). Ch 2, sk ch space, inc in the first st after the ch space, dc across until 5 sts remain. Leave the rest of the sts unworked.

Row 12 (14, 16, 18, 20): Turn. Slst into the next 5 sts starting in the 2nd st. Ch 3, dc across until one st remains before the ch space, inc. Ch 2, sk ch space, inc in the next 2 sts (4).

Continue alternating between the last two rows until you have a total of 14 (16, 18, 20, 22) rows.

Row 15 (17, 19, 21, 23): Turn. Slst in the 2nd st, slst in the 3rd st. Ch 3, inc two times. (4)

Row 16 (18, 20, 22, 24): Turn. Slst across 3 times starting in the 2nd st. Place another slst in the top of the ch 3. Ch 170 (190, 200, 220, 240) (this will be one of the strands that will cross in the back, you can adjust the length accordingly). Starting in the 2nd ch from the hook, slst across the ch. Slst in the st the ch started from, fasten off.

Lower Wing

Attach your yarn to the outer dc sts in the middle 3 sts from row 6.

Row 5 (7, 7, 9, 9): Ch 3, place 3 dc in the same st (3). Ch 2, sk ch space, dc across until the next ch space. Ch 2, sk ch space, inc in the next 2 sts (4). (16 (20, 20, 24, 24))

Row 6 (8, 8, 10, 10)- 9 (13, 13, 17, 17): Turn. Slst in the 2nd st, slst in the 3rd st. Ch 3, inc two times (4). Ch 2, sk ch space, sk first st, dc across until one st left before the next ch space. Ch 2, sk ch space, inc in the next 2 sts (4).

Row 10 (14, 14, 18, 18): You should have only one st left in the middle of the two ch spaces. Turn. Slst in the 2nd st, slst in the 3rd st. Ch 3, inc two times (4). Ch 1, sk the next 2 ch spaces. Inc in the next 2 sts (4). (8)

Row 11 (15, 15, 19, 19): Turn. Slst across 3 times starting in the 2nd st. Ch 3, dc in the same space. Ch 1, sk ch space, inc. (4 - ch 3 counts as a stitch this row). Fasten off.

Repeat the butterfly wing instructions for the other side of the butterfly's body.
Weave in all the ends.

The Straps

There are many ways you can tie this top to fit your body the best. Here is one way of doing it. The straps attached to the top of the butterfly's body will tie around your neck. Then, the other straps will first cross over the back and are put into the butterfly's upper wing's widest opening space. Then, the straps cross over again into the butterfly's lower wing's widest opening space. Then, the two strands are tied together.

Hide in all your ends and you're finished!

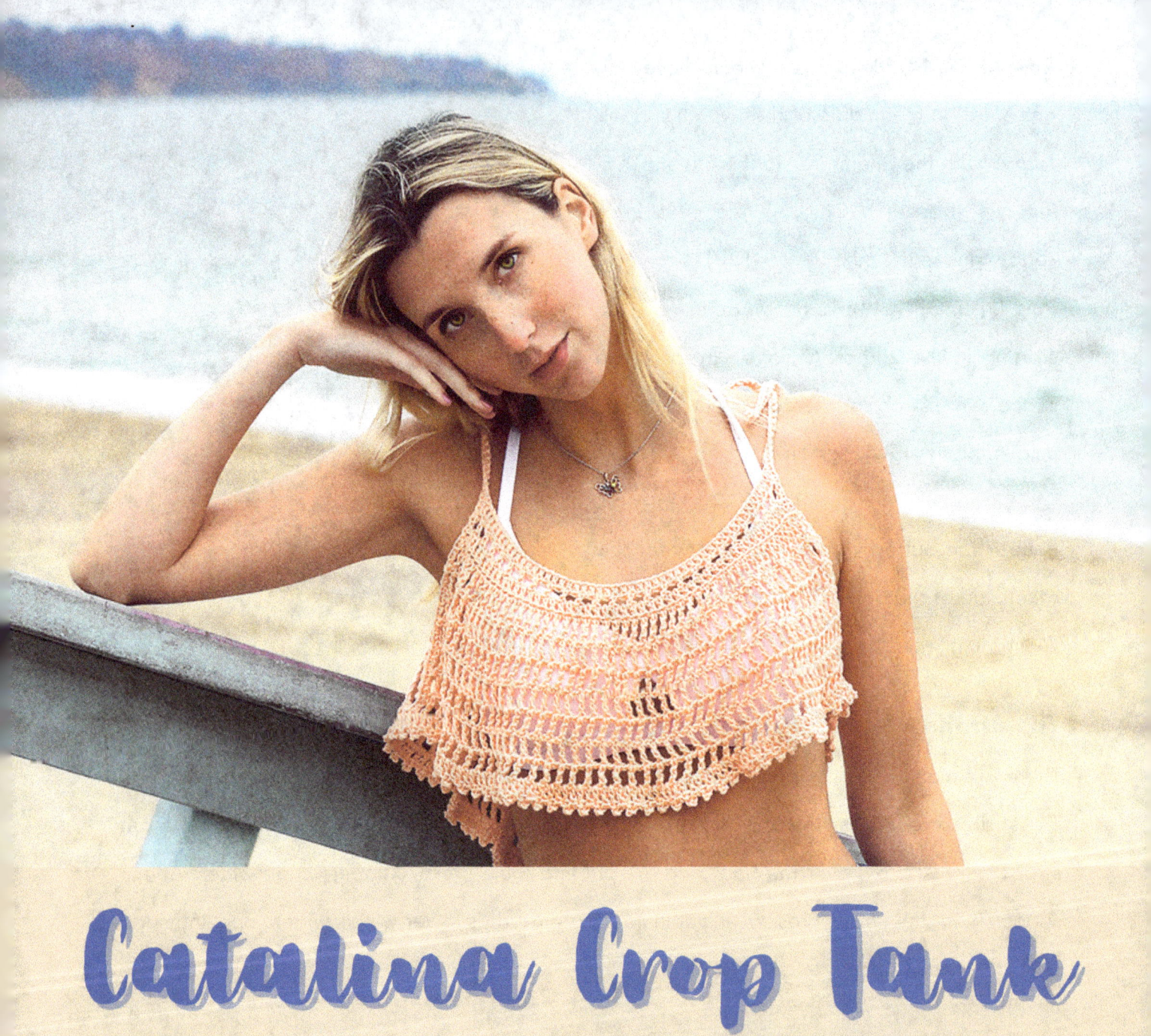

Materials

- **Yarn suggestions:** Fair Isle Harbor (purple example is made in Amethyst), Premier Cotton Fair (peach example is made in Coral), Cascade Ultra Pima Fine, Knit Picks Shine Sport
- **Hook:** US Size G/6 (4mm) or size needed to obtain gauge
- **Others:** yarn needle, scissors

Measurements

Size	Bust	Across bottom edge	Across neckline	Length
S	32-34"	25.5"	11"	7"
M	36-38"	27.5"	13"	8"
L	40-42"	29.5"	15"	9"
XL	44-46"	31.5"	17"	10"

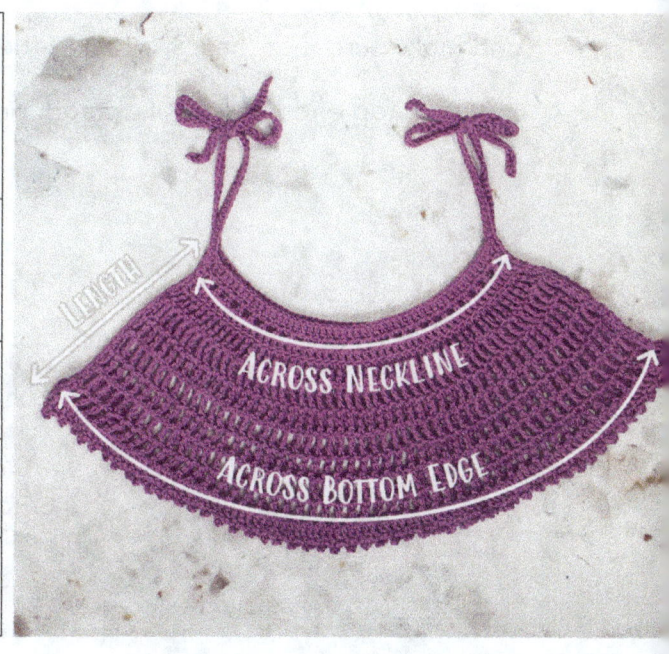

Pattern Notes

1. Top is made from two sides that are the same, worked separately, and then joined together at the bottom by working two rounds that go around both sides.

2. Each side is worked from the top down.

3. Straps are added last and are adjustable by tying them at the top of the shoulder.

4. Top is meant to be loose fitting and slightly oversized.

5. Work row 1 into back humps of ch to create a nicer edge. This will be the top edge/neckline of your top.

6. When working into the ch at the beginning and end of each strap, work sts into into back humps of ch to create a nicer edge.

7. When joining the two sides together, be aware of the right side (RS) of the top (see Photo A) and make sure that the RS is facing the same direction (face up or face down - see Photo B) so that your top ends up RS out on both sides.

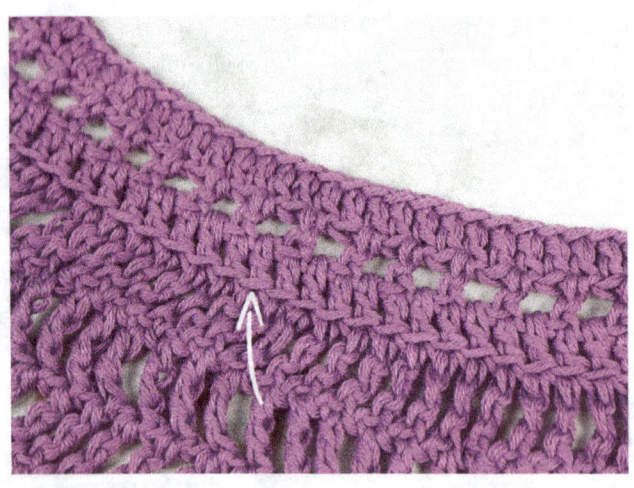

A

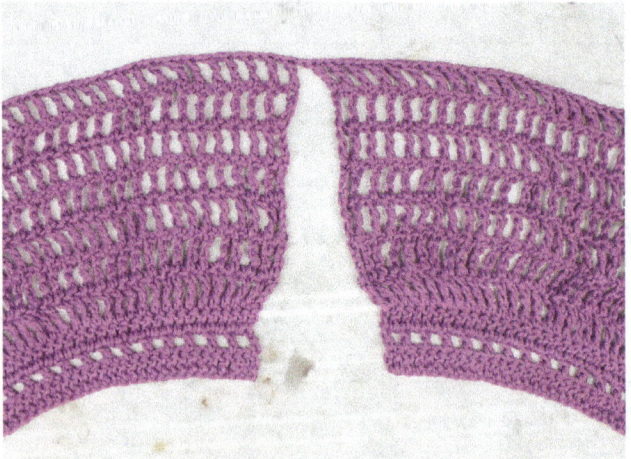

B

Side 1: Row 1 (RS): Ch (53, 57, 63, 67) (final 3 ch count as 1 dc), 1 dc in 4th ch from hook and in each ch across - (51, 55, 61, 65) dc.

Row 2: Ch 4 (counts as 1 dc + 1 ch) & turn, skip 1 st, 1 dc in next st, *ch 1, skip 1 st, 1 dc in next st; repeat from * across - (26, 28, 31, 33) dc + (25, 27, 30, 32) ch 1 spaces.

Row 3: Ch 3 (counts as 1 dc) & turn, *1 dc in next ch space, 1 dc in next st; repeat from * across - (51, 55, 61, 65) dc.

Row 4: Ch 5 (counts as 1 tr + 1 ch) & turn, 1 FLO tr in next st, *ch 1, 1 FLO tr in next st; repeat from * across - (51, 55, 61, 65) FLO tr + (50, 54, 60, 64) ch 1 spaces.

Row 5 - (9, 10, 11, 12): Ch 5 (counts as 1 tr + 1 ch) & turn, skip ch space, 1 tr in next st, *ch 1, skip ch space, 1 tr in next st; repeat from * across - (51, 55, 61, 65) tr + (50, 54, 60, 64) ch 1 spaces. Fasten off after the final row.

Side 2: Repeat instructions for side 1 but do not fasten off after the final row. Continue from there and work the following rounds to join the two sides.

Round 10: Ch 5 (counts as 1 tr + 1 ch) & turn, skip ch space, 1 tr in next st, *ch 1, skip ch space, 1 tr in next st; repeat from * across, ch 1, (you will now work into the final row of side 1, joining the two sides together) 1 tr in 1st st, **ch 1, skip ch space, 1 tr in next st; repeat from ** across, ch 1, sl st to join to 4th ch at beginning of round (on side 2) - (102, 110, 122, 130) tr + (102, 110, 122, 130) ch 1 spaces.

Round 11: Ch 3 (counts as 1 dc) & turn, 1 dc in next ch space, p, *1 dc in next st, 1 dc in next ch space, p; repeat from * around, invisible join to 3rd ch and fasten off - (204, 220, 244, 260) dc + (102, 110, 120, 130) p.

Straps

Leave a small tail at the beginning of the strap to make it easier to fasten off.

Ch (55, 61, 67, 73) 1 sc in 2nd ch from hook and in each remaining ch, (with RS of top facing out) join to top by making 1 sc in 1st st of row 1 (see Photo C), sc evenly in edge until you reach the bottom of that side, continue to sc evenly in edge of opposite side until you reach row 1 (see Photo D), ch 55, 1 sc in 2nd ch from hook and in each remaining ch, fasten off.

Repeat for other strap. Tie each strap in a bow.

Starting where you left off in the previous photo, you'll make another ch and single crochet into it. When you get back to the beginning of the ch, you'll fasten off. The photo below shows what your completed strap should look like. (Photo E)

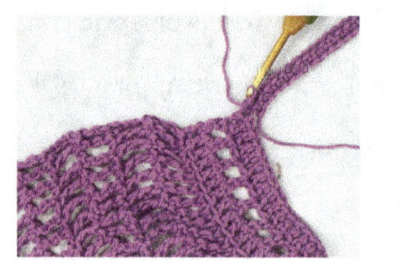

C

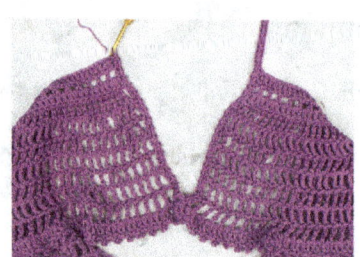

D

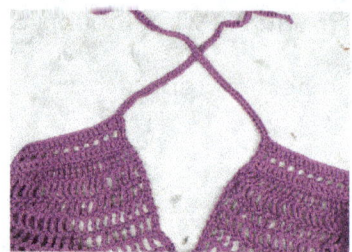

E

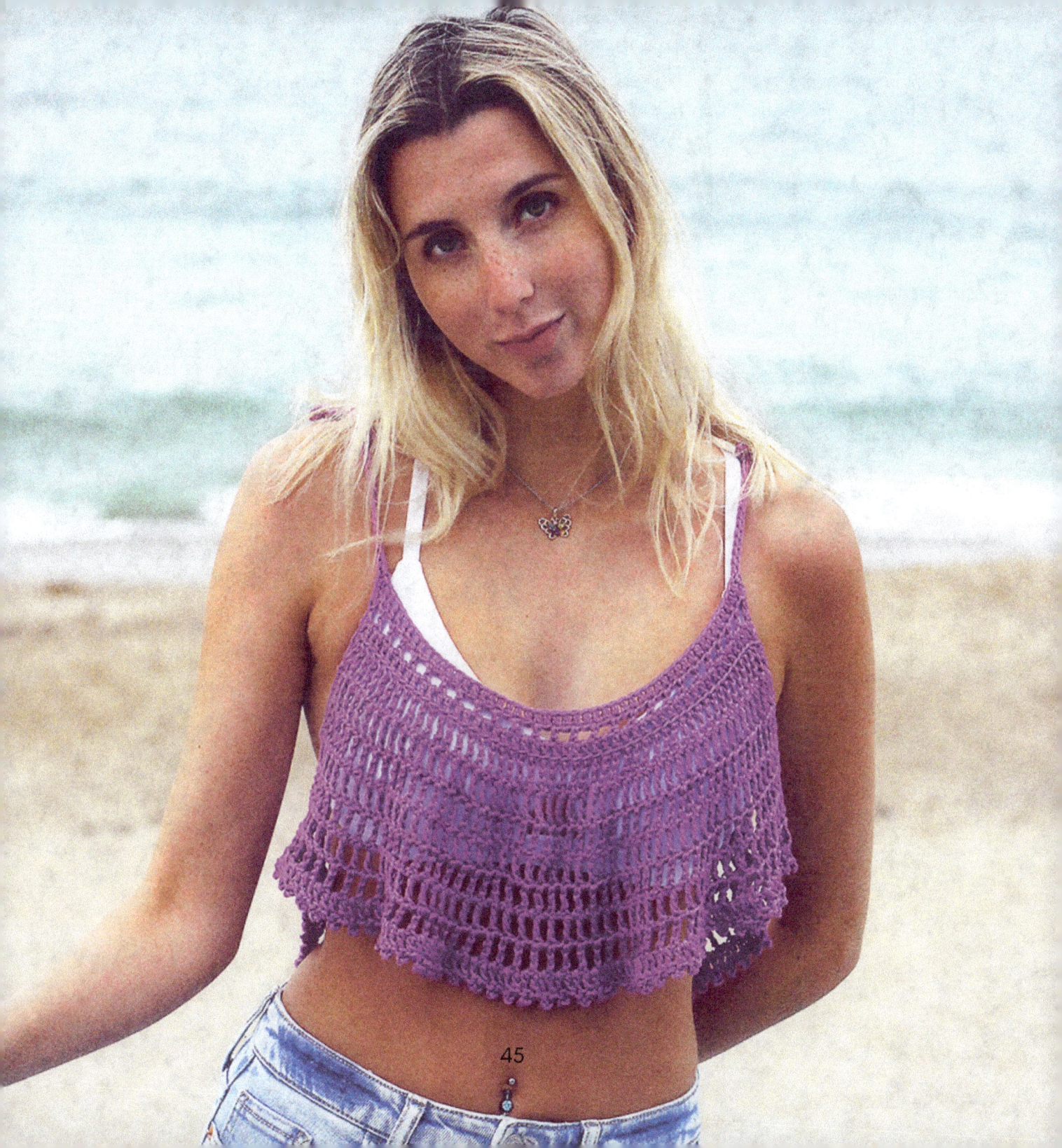

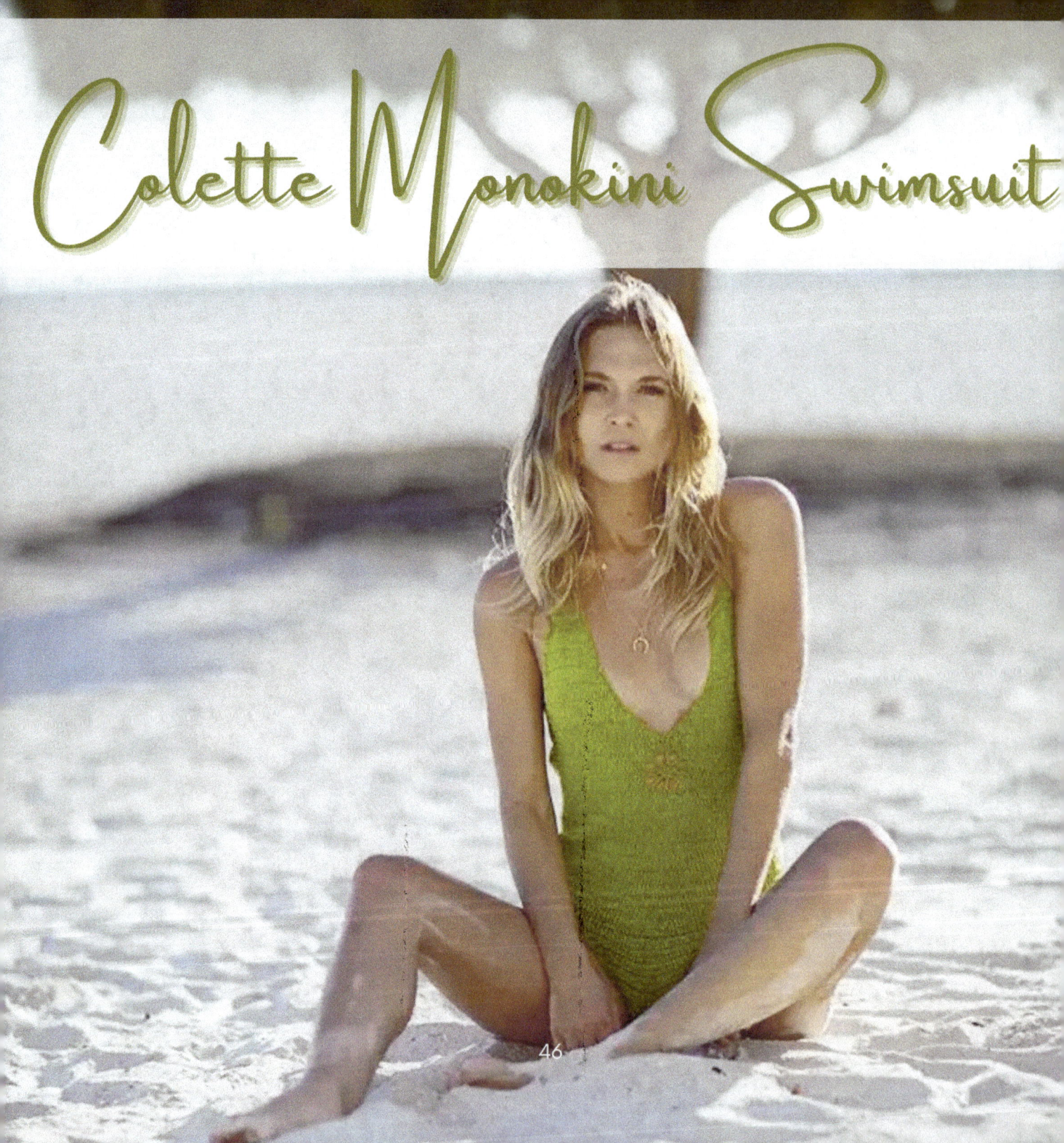
Colette Monokini Swimsuit

Materials

- **Crochet Swimsuit Yarn Recommendation**

When it comes to picking the perfect yarn for your crochet swimsuit, choosing the right yarn makes all the difference! Opting for a sport weight yarn with a blend of cotton and elastane or polymide is the key to creating a fabulous and functional swimwear piece.

Look for yarns specifically labeled as suitable for swimwear to ensure they can handle exposure to water and keep their shape and color intact.

Consider yarns like the Cascade Fixation Yarn.

This is a fantastic choice that brings together the softness of cotton with the stretch of elastane. Another great option is the **Alize Diva Stretch** yarns. This yarn offers a blend of polymide for added flexibility and comfort.

- **Hook:** size 2.25mm

- **Others:** tapestry needle, measuring tape, scissors, rubber band, stitch markers

Pattern Notes

- This swimsuit is stretchable when using mentioned yarn
- Turning chain does not count as a stitch unless mentioned otherwise.
- Hip size refers to the circumference of the widest part of your bum area and not the actual finished garment.
- Monokini length and cups are adjustable
- Your hip size: XS [S/ M/ L/ XL] - 32 [34/ 36/ 40/ 44] inches or 86 [91.5/ 101.5/ 111.5/ 122] cm (size up if you are in between sizes)

Pattern

PART 1: Front to Crotch to Back

Foundation Row: Ch 48[50/ 52/ 54/ 56] + Ch 1, turn

Row 1: On the 2nd Ch from hook, work a Hdc St and across, Ch1 turn

Row 2: Hdc2tog 2x, Hdc across until the last 5th St, Hdc2tog 2x, Ch 1 turn

Row 3 - 5: Rep Row 2 for 3 more rows. Ch1 turn

Row 6: Hdc2tog, Hdc across until the last 3rd St. Hdc2tog, Ch 1 turn

Row 7: Rep Row 6 for 10 [10/ 11/ 12/ 13] more rows. (10 [12/ 12/ 12/ 12] sts)

Next Row Crotch: Hdc same number of Sts across for 10 [12/ 13/ 14/ 15]rows. Ch 1 turn

Next Row: Work 2Hdc in the 1st St, Hdc across until the 2nd last St, 2Hdc. Ch 1 turn

Next Rows: Repeat step 8 increase for 26[28/30/ 32/ 34] total rows until the entire length reaches 13 [14/ 15/ 16/ 17] inches or 33 [35.6/ 38/ 40.6/ 43] cm ** Do not bind off**

PART 2: Join sides

From the last Hdc St, Ch 15 [15/ 16/ 21/ 26] Slst through FRONT sides 1st St. Bind off

Insert hook through the last Hdc St on the same row of the BACK side, draw up a loop and Ch 15[15/ 16/ 21/ 26], Slst through the FRONT sides last St of the 1st row, Ch 1, turn You should have approx. 17.5 [18.5/ 19.5/ 21.5/ 23.5] inches or 44.5 [47/ 49.5/ 54.6/ 59.7] cm hip width when fully stretched outwards. If not adjust accordingly

Hdc through the 1st St and around, Slst to join, Ch 1 turn (*We will turn our work at every new row and not work in the round)

Rep Step 3 for a total of 14 [14/ 14/ 12/ 12] rows. You should have 10 [10.5/ 11/ 11/ 11.5] inches or 25 [27/ 28/ 28/ 29] cm in total height from crotch . * Add or remove more rows if preferred. 1 Inch/ 2.5cm = 4 row. Bind off

Find the middle point on the BACK side, and count 23 [25/ 26/ 29/ 31] Stst to the left and again to the right of the center line and place a stitch marker (SM) on both ends. (see image 2)

Row 1: Facing the BACK side, insert hook through the left SM and Ch 1. Work Hdc on same St and across until the next SM. Ch 1 turn (see image 3)

Row 2 Decrease: Hdc2tog 2x, Hdc across until the last 5 Sts, Hdc2tog 2x, Ch 1 turn

Row 3 - 6: Rep Row 2 for 4 more rows, Ch 1 turn

Row 7 - 10: Hdc across for 4 more rows, Ch 1 turn

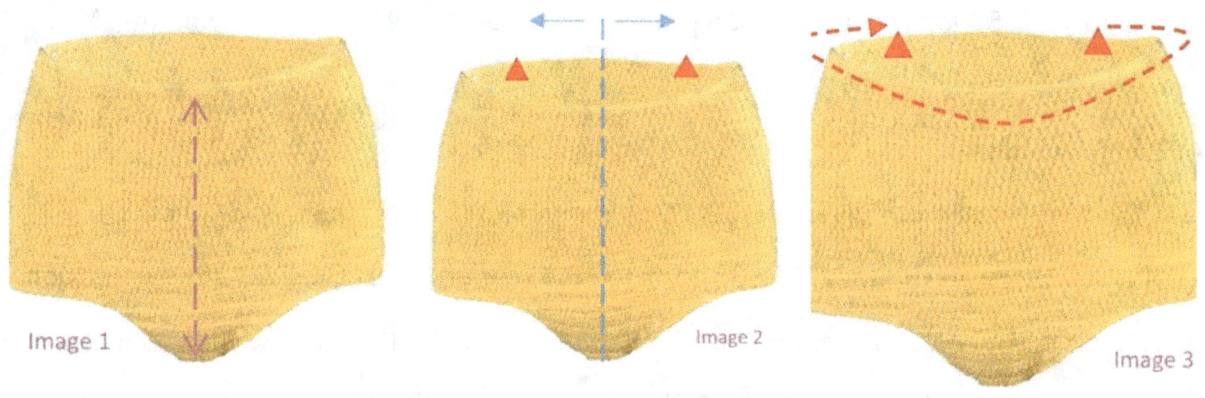

Image 1 Image 2 Image 3

PART 3: Flower motif

Row 11: Find the middle point on the FRONT side and place a SM. Work Hdc Sts until the 4th St before the SM. Ch5, Tc on the SM, Ch 5, Sk 3 Sts, Hdc on the 4th St after the SM, Hdc across, Ch 1 turn

Row 12: Hdc until the last 4th St, Ch5, work 1 Sc on the last Ch, Sc on the Tc St, Sc on the next Ch, Ch 5, Sk 3 Sts, Hdc on the 4th St across, Ch 1 turn

Row 13: Hdc until the last 4th St, Ch5, work 1 Sc on the last Ch, Sc 3, Sc on the next Ch, Ch 5, Sk 3 Sts, Hdc on the 4th St across, Ch 1 turn

Row 14: Hdc till the last St, Ch5, Sk 1 St, Sc 3, Sk 1 St, Ch 5, Hdc the 1st St and across, Ch 1 turn

Row 15: Hdctill the last St, Work 3 Hdc Sts on Ch, Ch3, Sk 1 St, Tc on the 2ndSt, Sk 1 St, Ch3, work 3 Hdc Sts on Ch, Hdc on the next St and across, Ch 1 turn

Row 16 - 17: Hdc across for 2 more rows, Ch 1 turn

* You may add more rows here to determine how high/low you would like the cleavage to be. Every 4 rows = 1 inch /2.5cm.

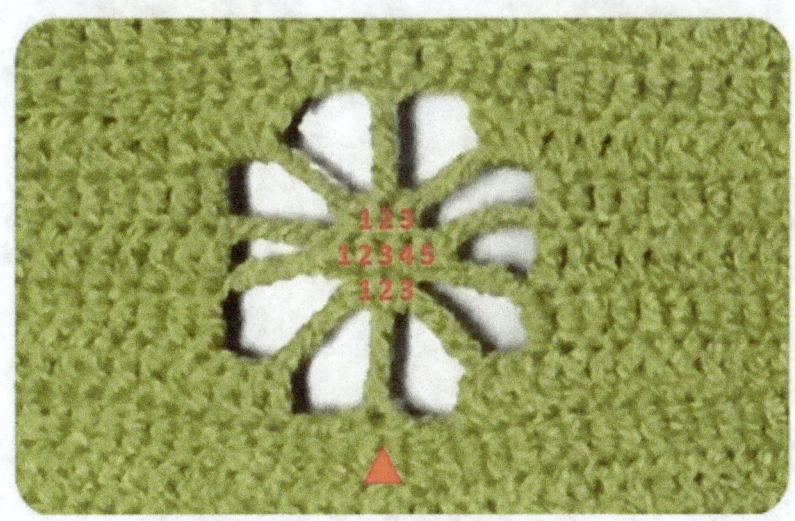

PART 4: Split top for cups & Make ties

Row 18: Find the middle point on the FRONT side and place a SM. From the last St, *(Hdc2tog, Hdc across until the last 3rd St before marker, Hdc2tog, Ch 1 turn)

Next Rows: Rep (*) until you have 2 Sts remaining.

Last row: Before completing the last Hdc2tog St, add ties by joining a second yarn then close the last Hdc2tog St by pulling through both yarns. Work 100 double chain, bind off

Rep on the other side.

Insert hook through the last rows post where the top splits, attach 2 yarns and chain 100 to make back tie.

Rep on the other side.

Bind off

Part 5: Inserting Rubberband

On the last st RS, place rubber band at the back of the row.

Work a Sc over and around the band

The elastic band should be between Sts

Cont to Sc around the band

Before closing St, stop approx 2 in/ 5cm and pull elastic band slightly on both ends.

Tie 2 knots

Cont to Sc around the band hiding both band and knot. Slst to close.

Snip off remaining band and weave in loose ends.

Best to use round elastic band.

Turn to the back of the bottoms, and insert hook through the last St, where the SM was.

Place rubber band behind row and Sc across and around rubber band

Pull firmly and tie a double knot on both ends of elastic band. Snip off access.

Bind off and weave in all loose ends.

After Care Guide

1. Washing Instructions: Gently hand wash your crochet swimsuit using a mild detergent in cool water. Avoid using harsh chemicals or bleach, as they can damage the fibers and colors.

2. Drying Methods: After washing, it's crucial to choose the right drying method. You can either:

- Low Tumble Heat: If using a dryer, set it to low tumble heat to avoid excessive heat exposure. Keep in mind that high heat can damage the yarn and affect the shape of your swimsuit.

- Lay Flat to Dry: Alternatively, lay your swimsuit flat on a clean, dry towel to air dry. This method helps maintain the shape and prevents stretching.

3. Storage Tips: Store your crochet swimsuit in a cool, dry place away from direct sunlight. Avoid folding or compressing it for extended periods to prevent creases or misshaping.

4. Rinse After Use: If your crochet swimsuit has been exposed to saltwater, chlorine, or sunscreen, it's advisable to rinse it with cool water after each use. This helps remove any residue that may affect the color and integrity of the yarn.

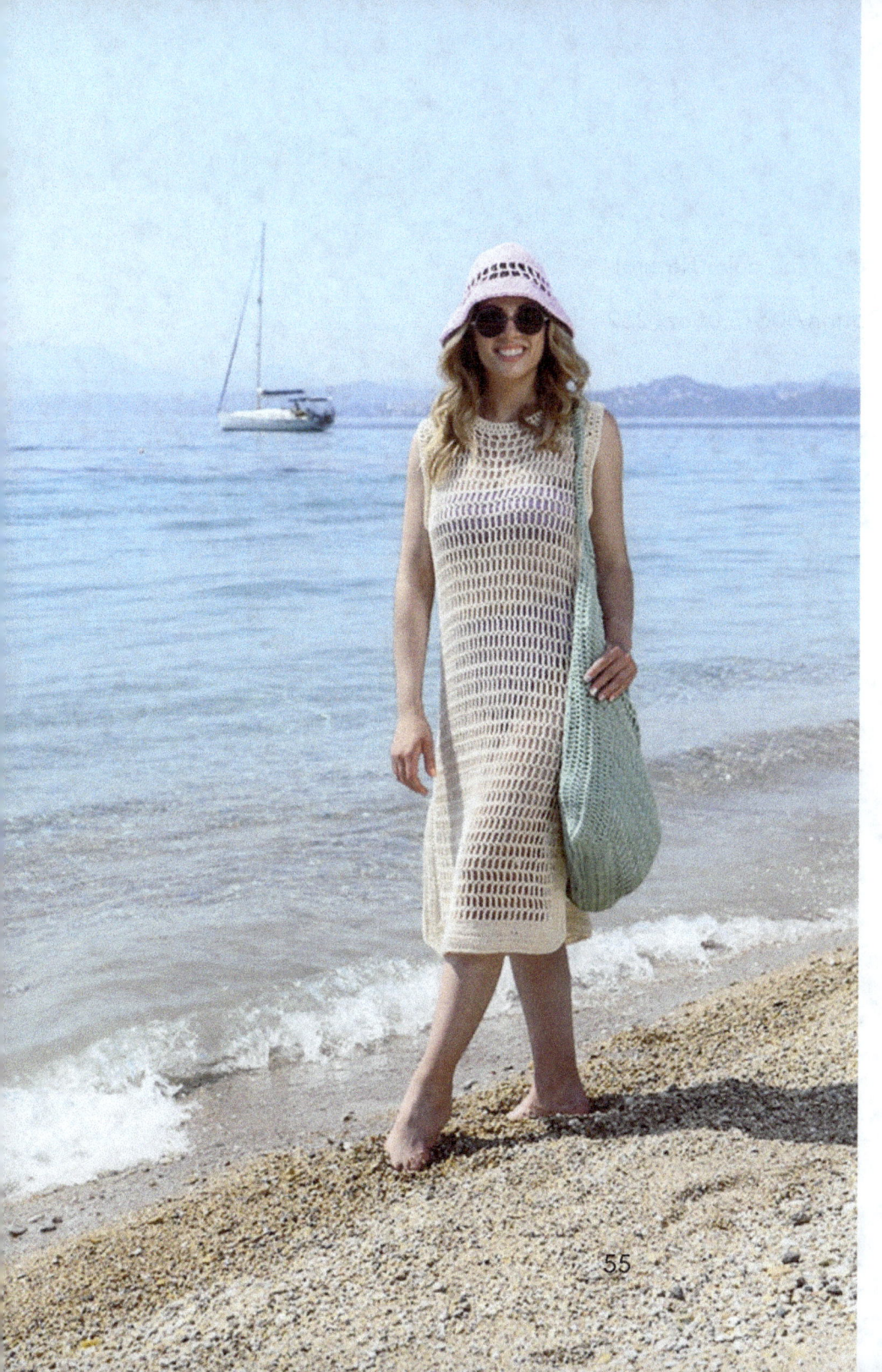

BEACH COVER-UP

MATERIALS

Yarn

We Are Knitters - The Cotton in the color Natural.

This cotton is 100% Pima Cotton/10g/3.05oz/232 yds/212m.

Hook

5 mm (US H/8) crochet hook.

Notions

- Scissors
- Darning needle
- Tape measure

MEASUREMENTS/SIZES

XS - To fit bust 34 inches.

S - To fit bust 36 inches.

M - To fit bust 38 inches.

L - To fit bust 40 inches.

XL - To fit bust 42 inches.

2XL - To fit bust 44 inches.

3XL - To fit bust 46 inches.

4XL/5XL - To fit bust 48 inches.

The dress measures - length to shoulders around = 39 (39, 39, 39.5, 39.5, 40, 40, 40.5) inches.

PATTERN

Back

** Ch 78 (84, 90, 96, 102, 108, 114, 120)

Set up

Work 1 dc into 2nd ch from hook, 1 dc into each ch to end. 77 (83, 89, 95, 101, 107, 113, 119) sts.

Start Pattern

Row 1: 4 ch, for the first tr and ch, miss 1 st, 1 tr into next st, * 1 ch, miss 1 st, 1 tr into next st, rep from * to end.

Row 2: 4 ch for the first tr and ch, 1 tr into next tr, * 1 ch, miss 1 ch, 1 tr into 1 tr, rep from * to end working last tr into 3rd of 4 ch, turn,

Rep row 2 until the work measures: 15 (15, 15, 16, 16, 16, 17, 17,) inches from the setup row.

Next row (decrease row): 4 ch for the first tr and ch, 1 tr into next tr, 1 ch, work next tr2tog, 1 ch, patt to last 7 sts, work next tr2tog, 1 ch, 1 tr into next tr, 1 ch, 1 tr into the last st. 75 (81, 87, 93, 99, 105, 111, 117)

Continue without further decreases until the work measures 25 inches from the start of the setup row, finishing on a wrong side row.

(You can adjust the length here - if you want to make it shorter or longer)*

Shape Armholes

Next row: sl st over 6 (6, 6, 6, 8, 8, 8, 8) sts, pattern to last 6 (6, 6, 6, 8, 8, 8, 8) sts, turn,

Next row: 4 ch for first tr and ch, 1 tr into next tr, 1 ch, work next tr2tog, 1 ch, patt to the last 7 sts, work next tr2tog, 1 ch, 1 tr into next tr, into last st.

Rep the last row twice more – 57 (63, 69, 75, 77, 83, 89, 95) sts. **

Cont without further dec until the armhole measures 6 (6, 6, 6.5, 6.5, 7, 7, 7.5) inches, ending on a wrong side row.

Shape Shoulders and Back of Neck

Next row: sl st over 8 (8, 8, 8, 10, 10, 10, 10) sts, patt over 13 (13, 13, 13, 15, 15, 15, 15) sts, fasten off.

Miss the next 15 (21, 27, 33, 27, 33, 39, 45) sts for neck edge, rejoin yarn into next st, patt over 13 (13, 13, 13, 15, 15, 15, 15) sts.

Fasten off.

You should have 8 (8, 8, 8, 10, 10, 10, 10) sts remaining for the shoulder edge.

The Edging

With the right side of the work facing you, rejoin the yarn at the start of the armhole shaping.

Work 1 row of dc evenly down the left side edge, round the lower edge, and up the right side edge, to the start of the armhole shaping, working 2 dc into the end of each of 2 rows and 3 dc into the end of the next row.

Work 2 more rows in dc, working 3 dc into each corner st and turning with 1 ch.

Fasten off.

Front

Work exactly as instructions for the back from ** to **.

Cont without further dec until armhole measures 2 inches less than back armhole to shoulder shaping.

Next row: Patt across 18 (20, 22, 24, 24, 26, 28, 30) sts, turn,

Cont over these sts as follows:

Next row: 4 ch for the first tr and ch, 1 tr into next tr, 1 ch, work next tr2tog, 1 ch, patt to end.

Cont without further dec until armhole measures 6 (6, 6, 6.5, 6.5, 7, 7, 7.5) inches, ending on a wrong side row.

Shape Shoulder

Next row: sl st over 8 (8, 8, 8, 10, 10, 10, 10) sts, patt to end, fasten off.

Miss 21 (23, 25, 27, 29, 31, 33, 35) sts for neck edge, rejoin yarn to rem 18 (20, 22, 24, 24, 26, 28, 30) sts, and work to correspond with the other side, reversing all shaping

Work the dc border around the sides and lower edge the same as for the back piece.

Finishing: Join the shoulder seams by backstitching.

The Neckband: With the right side of the work facing you, rejoin the yarn.

Work 1 row of dc evenly around the neck edge, turn with 1 ch. Work 1 more row of dc. Fasten off.

The Armhole Edges: Work the armhole edges in the same manner as the neck.

Side Seams: Join side seams using the mattress stitch, leaving 10 or 12 inches open at the lower edge of each side seam.

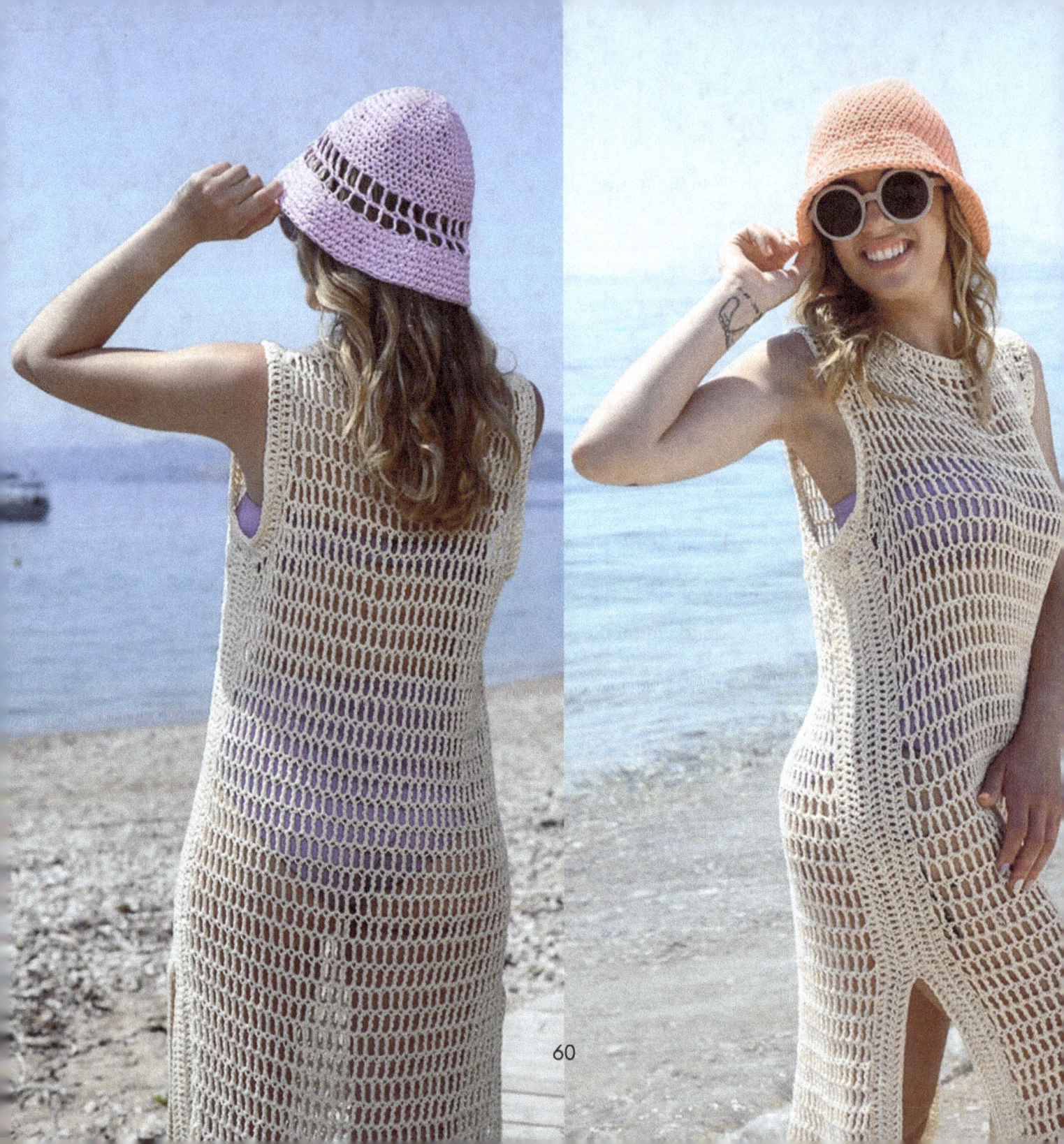

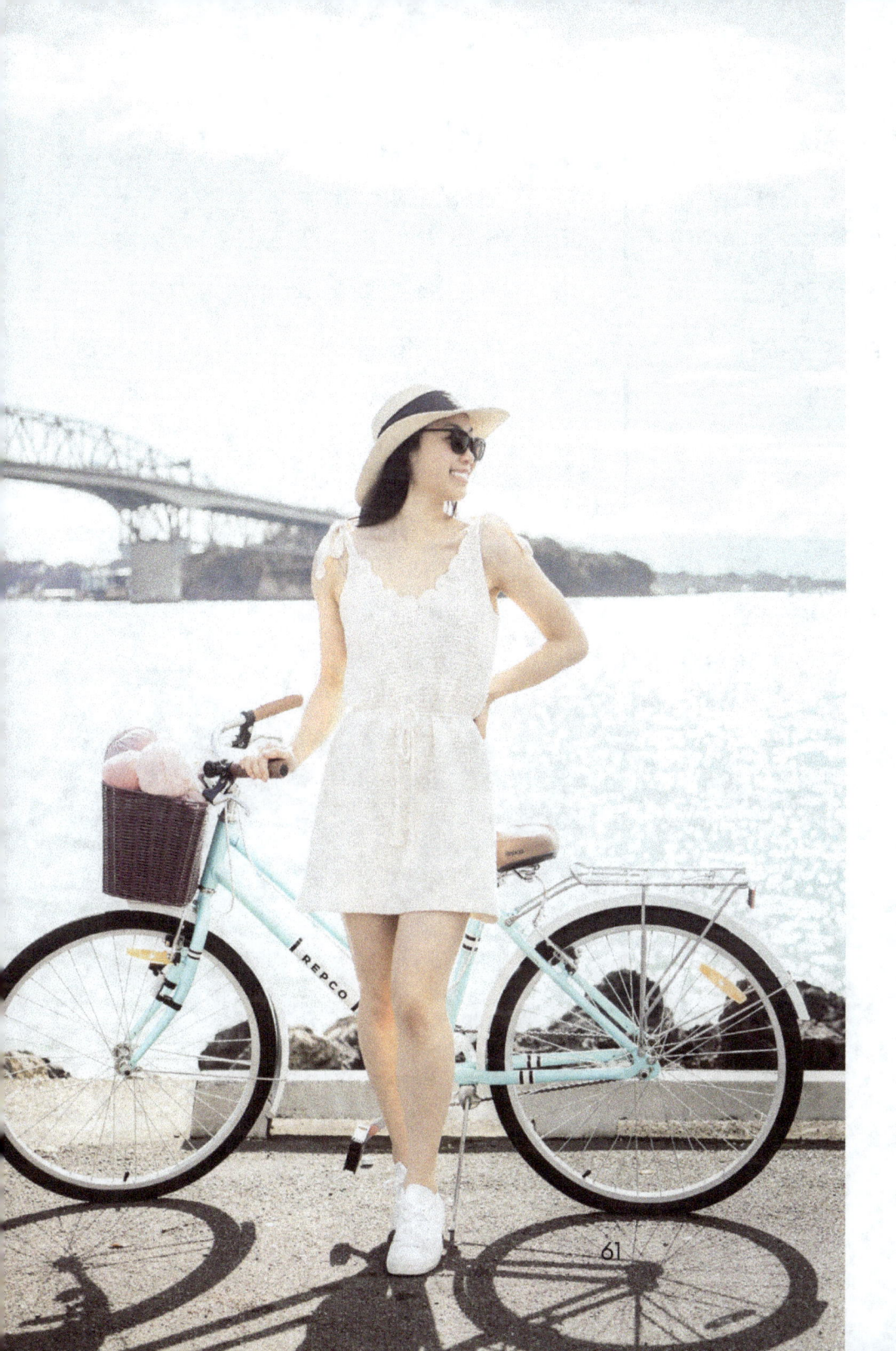

Scallop Summer Dress

Materials

Yarn: WeCrochet Simply Cotton Organic Sport – Sport/Fine (2), 150m/50g, 164yds/1.75 oz, 100% Organic Cotton

Crochet Hook: 3.75mm (US F)

Notions:
- Darning Needle
- Scissors
- 6 Safety pins/stitch markers

Measurements

Size XS, (S, M, L, XL, 2XL, 3XL)

Bust: 30.5 (34, 37, 40, 44, 47.5, 53)"

Dress Length: 29 (29.5, 30, 30.5, 31, 31.5, 32)"

Pattern

STRAP + RIGHT TRIANGLE

(make 2)

STRAP

Foundation chain: Ch 5(5, 5, 5, 9, 9, 9).

Row 1: SC into 2nd ch from hook, SC in each st until end, turn. <4(4, 4, 4, 8, 8, 8)>

Row 2: Ch 1, SC across, turn. <4(4, 4, 4, 8, 8, 8)>

Straight straps: Repeat ROW 2 until ROW 12(12, 14, 14, 16, 16, 18).

TIE STRAPS: Repeat ROW 2 until ROW 84(84, 86, 86, 88, 88, 90).

Do not fasten off! Proceed directly to 'Right Triangle' instructions.

RIGHT TRIANGLE

Row 1 (RS): Ch 1, 2SC, SC in each st until last st, 2SC in last st, turn. <6(6, 6, 6, 10, 10, 10)>

*You can place a SM in first row to make it easier to count the triangle rows and to indicate the RS.

Row 2: Ch 1, SC across turn. <6(6, 6, 6, 10, 10, 10)>

Row 3: Ch 1, SC in each st until last st, 2SC, turn. <7(7, 7, 7, 11, 11, 11)>

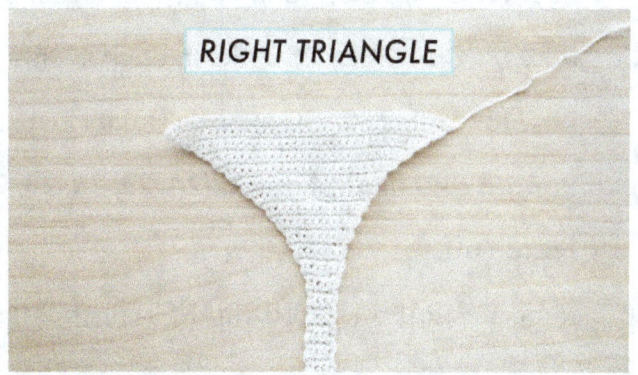

Row 4: Ch 1, SC across, turn. <7(7, 7, 7, 11, 11, 11)>

Row 5: Ch 1, SC in each st until last st, 2SC, turn. <8(8, 8, 8, 12, 12, 12)>

Row 6: Ch 1, SC in each st until last st, 2SC, turn. <9(9, 9, 9, 13, 13, 13)>

Row 7: Ch 1, SC in each st until last st, 2SC, turn. <10(10, 10, 10, 14, 14, 14)>

Row 8: Ch 1, 2SC, SC in each st until last st, 2SC in last st, turn. <12(12, 12, 12, 16, 16, 16)>

Repeat Rows 5 - 8 until Row 16.

Row 9: Ch 1, SC in each st until last st, 2SC, turn. <13(13, 13, 13, 17, 17, 17)>

Row 10: Ch 1, SC in each st until last st, 2SC, turn. <14(14, 14, 14, 18, 18, 18)>

Row 11: Ch 1, SC in each st until last st, 2SC, turn. <15(15, 15, 15, 19, 19, 19)>

Row 12: Ch 1, 2SC, SC in each st until last st, 2SC in last st, turn. <17(17, 17, 17, 21, 21, 21)>

Row 13: Ch 1, SC in each st until last st, 2SC, turn. <18(18, 18, 18, 22, 22, 22)>

Row 14: Ch 1, SC in each st until last st, 2SC, turn. <19(19, 19, 19, 23, 23, 23)>

Row 15: Ch 1, SC in each st until last st, 2SC, turn. <20(20, 20, 20, 24, 24, 24)>

Row 16: Ch 1, 2SC, SC in each st until last st, 2SC in last st, turn. <22(22, 22, 22, 26, 26, 26)>

Row 17: Ch 1, 2SC, 2SC, SC in each st until last st, 2SC in last st, turn. <25(25, 25, 25, 29, 29, 29)>

Row 18: Ch 1, 2SC, SC in each st until last st, 2SC in last st, turn. <27(27, 27, 27, 31, 31, 31)>

Repeat row 18 until row 22(24, 26, 28, 28, 30, 34). <35(39, 43, 47, 51, 55, 63)>

Fasten off.

Repeat STRAPS + RIGHT TRIANGLE instructions.

Row-by-Row Stitch Count:

Row 19: Ch 1, 2SC, SC in each st until last st, 2SC in last st, turn. <29(29, 29, 29, 33, 33, 33)>

Row 20: Ch 1, 2SC, SC in each st until last st, 2SC in last st, turn. <31(31, 31, 31, 35, 35, 35)>

Row 21: Ch 1, 2SC, SC in each st until last st, 2SC in last st, turn. <33(33, 33, 33, 37, 37, 37)>

Row 22: Ch 1, 2SC, SC in each st until last st, 2SC in last st, turn. <35(35, 35, 35, 39, 39, 39)>

Size XS - final row

Row 23: Ch 1, 2SC, SC in each st until last st, 2SC in last st, turn. <(37, 37, 37, 41, 41, 41)>

Row 24: Ch 1, 2SC, SC in each st until last st, 2SC in last st, turn. <(39, 39, 39, 43, 43, 43)>

Size S - final row

Row 25: Ch 1, 2SC, SC in each st until last st, 2SC in last st, turn. <(41, 41, 45, 45, 45, 45)>

Row 26: Ch 1, 2SC, SC in each st until last st, 2SC in last st, turn. <(43, 43, 47, 47, 47)>

Size M - final row

Row 27: Ch 1, 2SC, SC in each st until last st, 2SC in last st, turn. <(45, 49, 49, 49)>

Row 28: Ch 1, 2SC, SC in each st until last st, 2SC in last st, turn. <(47, 51, 51, 51)>

Size L + XL - final row

Row 29: Ch 1, 2SC, SC in each st until last st, 2SC in last st, turn. <(53, 53)>

Row 30: Ch 1, 2SC, SC in each st until last st, 2SC in last st, turn. <(55, 55)>

Size 2XL - final row

Row 31: Ch 1, 2SC, SC in each st until last st, 2SC in last st, turn. <(57)>

Row 32: Ch 1, 2SC, SC in each st until last st, 2SC in last st, turn. <(59)>

Size 3XL - final row

Row 33: Ch 1, 2SC, SC in each st until last st, 2SC in last st, turn. <(61)>

Row 34: Ch 1, 2SC, SC in each st until last st, 2SC in last st, turn. <(63)>

STRAP + LEFT TRIANGLE

(make 2)

STRAP

FOUNDATION CHAIN: Ch 5(5, 5, 5, 9, 9, 9).

ROW 1: SC into 2nd ch from hook, SC in each st until end, turn.

<4(4, 4, 4, 8, 8, 8)>

ROW 2: Ch 1, SC across, turn.

<4(4, 4, 4, 8, 8, 8)>

STRAIGHT STRAPS: Repeat ROW 2 until ROW 12(12, 14, 14, 16, 16, 18).

TIE STRAPS: Repeat ROW 2 until ROW 84(84, 86, 86, 88, 88, 90).

Do not fasten off! Proceed directly to 'Left Triangle' instructions.

LEFT TRIANGLE

ROW 1 (RS): Ch 1, 2SC, SC in each st until last st, 2SC in last st, turn. <6(6, 6, 6, 10, 10, 10)>

*You can place a SM in first row to make it easier to count the triangle rows and to indicate the RS.

ROW 2: Ch 1, SC across, turn. <6(6, 6, 6, 10, 10, 10)>

ROW 3: Ch 1, 2SC, SC across, turn. <7(7, 7, 7, 11, 11, 11)>

ROW 4: Ch 1, SC across, turn. <7(7, 7, 7, 11, 11, 11)>

ROW 5: Ch 1, 2SC, SC across, turn. <8(8, 8, 8, 12, 12, 12)>

ROW 6: Ch 1, 2SC, SC across, turn. <9(9, 9, 9, 13, 13, 13)>

ROW 7: Ch 1, 2SC, SC across, turn. <10(10, 10, 10, 14, 14, 14)>

ROW 8: Ch 1, 2SC, SC in each st until last st, 2SC in last st, turn. <12(12, 12, 12, 16, 16, 16)>

Repeat ROWS 5 - 8 until ROW 16.

ROW 9: Ch 1, 2SC, SC across, turn. <13(13, 13, 13, 17, 17, 17)>

ROW 10: Ch 1, 2SC, SC across, turn. <14(14, 14, 14, 18, 18, 18)>

ROW 11: Ch 1, 2SC, SC across, turn. <15(15, 15, 15, 19, 19, 19)>

ROW 12: Ch 1, 2SC, SC in each st until last st, 2SC in last st, turn. <17(17, 17, 17, 21, 21, 21)>

ROW 13: Ch 1, 2SC, SC across, turn. <18(18, 18, 18, 22, 22, 22)>

ROW 14: Ch 1, 2SC, SC across, turn. <19(19, 19, 19, 23, 23, 23)>

ROW 15: Ch 1, 2SC, SC across, turn. <20(20, 20, 20, 24, 24, 24)>

ROW 16: Ch 1, 2SC, SC in each st until last st, 2SC in last st, turn. <22(22, 22, 22, 26, 26, 26)>

ROW 17: Ch 1, 2SC, SC in each st until last 2 sts, 2SC, 2SC in last st, turn. <25(25, 25, 25, 29, 29, 29)>

ROW 18: Ch 1, 2SC, SC in each st until last st, 2SC in last st, turn. <27(27, 27, 27, 31, 31, 31)>

Repeat ROW 18 until ROW 22(24, 26, 28, 28, 30, 34). <35(39, 43, 47, 51, 55, 63)>

*(*Please refer to Right Triangle ROWS 19 - 34 instructions for the row-by-row stitch count)*

Fasten off.

Repeat STRAPS + LEFT TRIANGLE instructions but for the 2nd Left Triangle do not fasten off! Proceed directly to 'JOINING ROW' instructions.

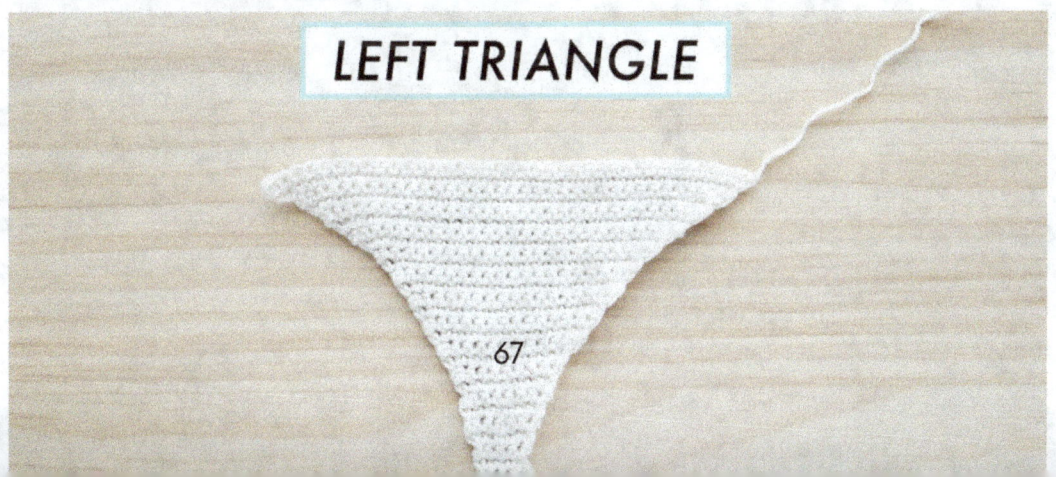

LEFT TRIANGLE

JOINING ROW

Ch 1, 2SC, SC in each st until last 2 sts, 2SC, 2SC in last st. <38(42, 46, 50, 54, 58, 66)>

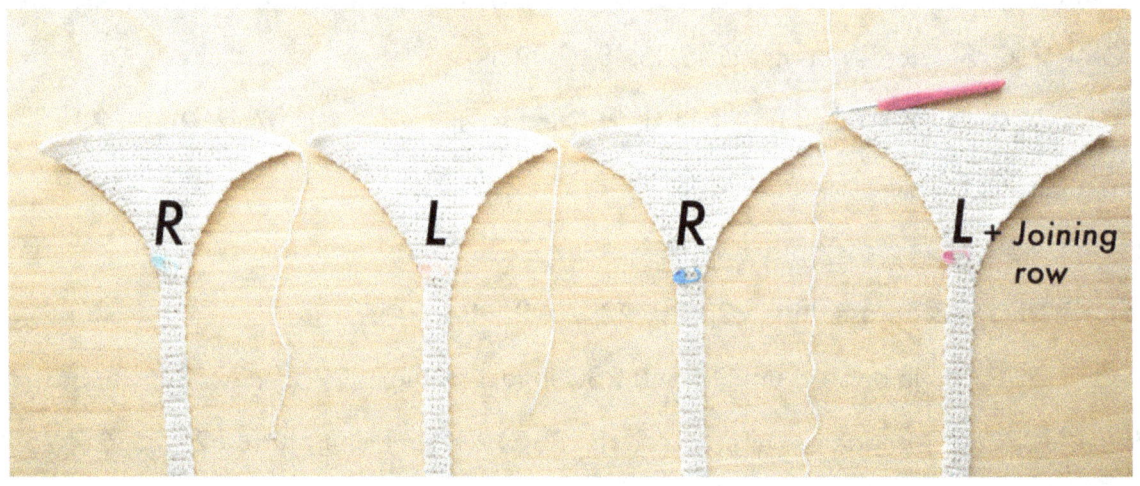

With the RS facing, place a Right Triangle the left of the Left Triangle.

2SC into the first st of the Right Triangle, 2SC, SC in each st until last st, 2SC in last st.

<76(84, 92, 100, 108, 116, 132)>

With the RS facing, place the 2nd Left Triangle the left of the Right Triangle.

2SC into the first st of the 2nd Left Triangle, SC in each st until last 2 sts, 2SC, 2SC in last st.

<114(126, 138, 150, 162, 174, 198)>

With the RS facing, place the 2nd Right Triangle the left of the 2nd Left Triangle.

2SC into the first st of the 2nd Right Triangle, 2SC, SC in each st until last st, 2SC in last st.

<152(168, 184, 200, 216, 232, 264)>

Sl st into the 1st st of the Left Triangle to join, turn. Make sure that your 4 triangles aren't twisted!

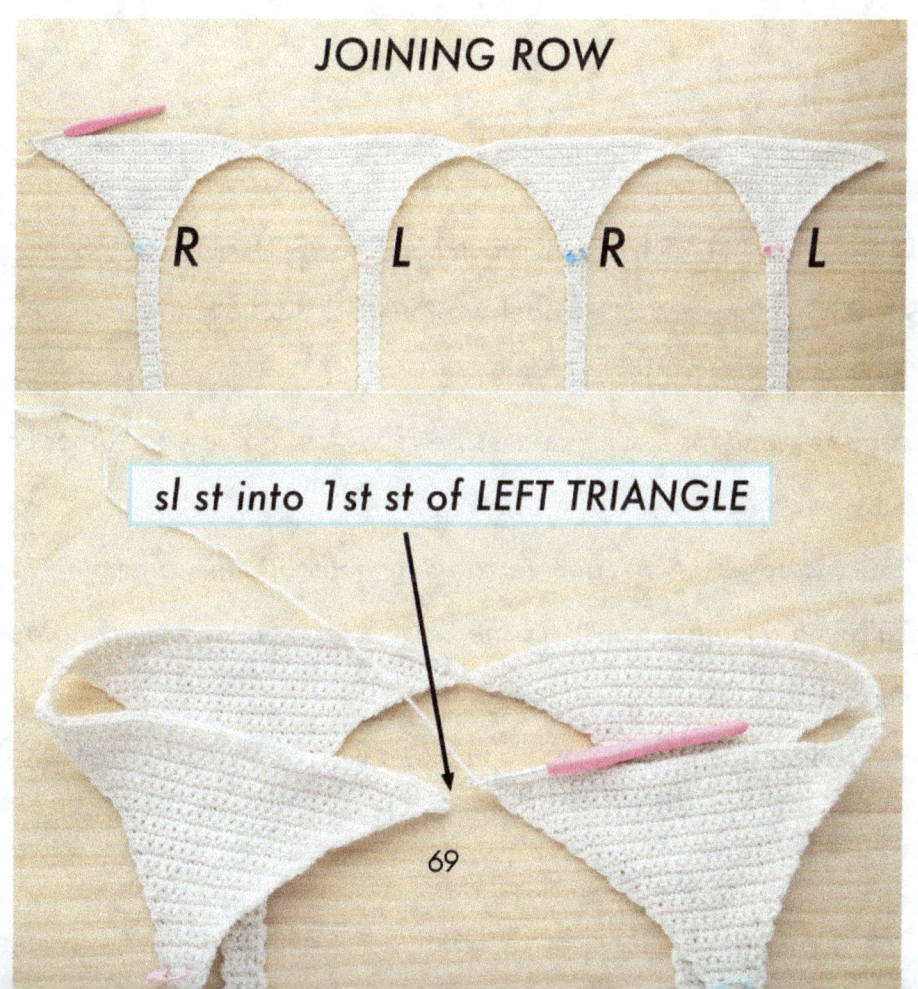

BODY

BODY ROUNDS 1 - 3: Ch 1, SC around, sl st to join, turn. <152(168, 184, 200, 216, 232, 264)>

The sl sts form a 'seam' that runs down the centre back of the dress.

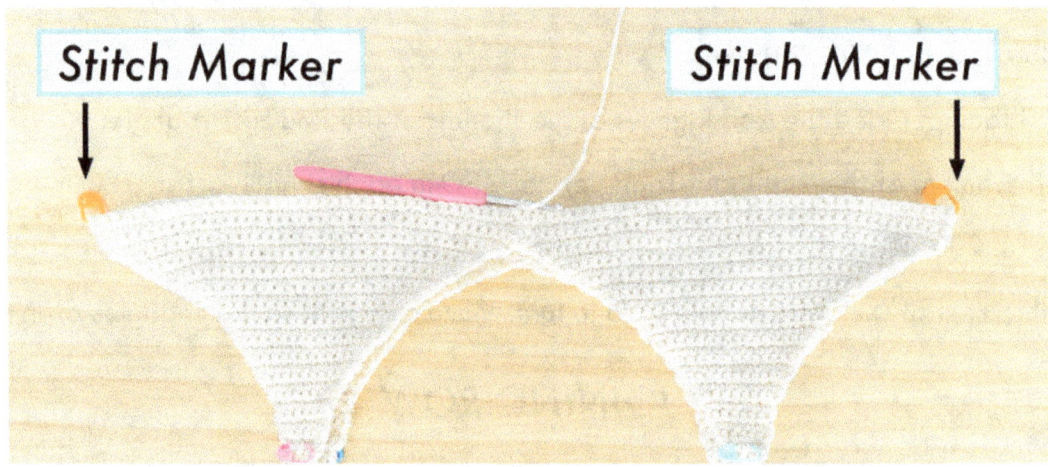

Place a SM underneath each armhole.

BODY ROUND 4: Ch 1, SC in each st until around 1st SM, 2SC - place SM, SC in each st until around 2nd SM, 2SC - place SM, SC in each st around, sl st to join, turn.

<154(170, 186, 202, 218, 234, 266)>

You do not need to place the 2SC increases perfectly 'on top' of each other or in the same st with a SM.

Place the 2SC increases in the general area underneath the armhole (varying the st placement results in a smoother hemline) - the SM just serves as a reminder of roughly where and which round to increase.

Repeat BODY ROUNDS 1 - 4 until BODY ROUND 60. <182(198, 214, 230, 246, 262, 294)>

SKIRT

ROUND 1 – 5: Ch 1, SC around, sl st to join, turn.

ROUND 6: Ch 1, SC in each st until around 1st SM, 2SC – place SM, SC in each st until around 2nd SM, 2SC – place SM, SC in each st around, sl st to join, turn.

<184(200, 216, 232, 248, 264, 296)>

Repeat SKIRT ROUNDS 1 – 6 until SKIRT ROUND 72 or until you reach your desired length.

<206(222, 238, 254, 270, 286, 318)>

Keep in mind that the dress will lengthen after wear.

Fasten off.

STRAIGHT STRAPS ASSEMBLY + FINISHING

Sew the tops of the straps together.

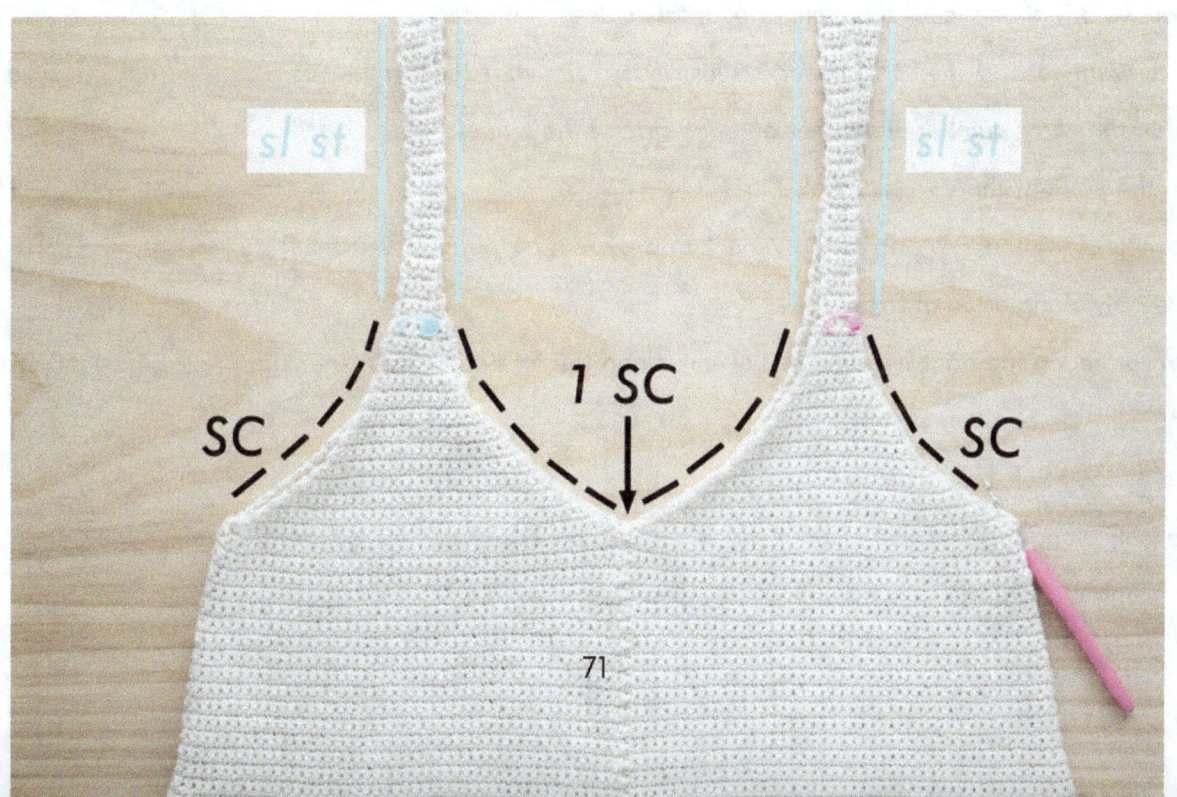

ARMHOLE FINISHING

With the RS facing, insert hook at the top of the strap, secure yarn and pull up a loop, ch 1 - place SM.

Sl st evenly along edge of strap, SC evenly along edge of armhole, sl st evenly along edge of strap until SM, sl st into 1st st to join.

Fasten off. Repeat for 2nd armhole.

NECKLINE FINISHING

SMs only necessary for scallop edge.

With the RS facing, insert hook at the top of the strap, secure yarn and pull up a loop, ch 1 - place SM.

Sl st evenly along edge of strap, when you reach the V-neckline SC evenly along 1st side of V-neck approx. SC 24(24, 30, 30, 30, 30, 36) - place SM in first SC,

Depending on your tension you might need to add or remove SCs.

If you want a plain v-neck the number of stitches doesn't matter.

If you want to add the scallop edging just make sure that the number of SCs is a multiple of 6 and crochet the same number of stitches on each side of the v-neck.

SC in the point of the V - place SM,

SC evenly along the 2nd side of the V-neck approx. 24(24, 30, 30, 30, 30, 36) sts,

Sl st evenly along edge of strap.

When you reach the back neckline, SC evenly along the 1st side of the V-neck approx. 24(24, 30, 30, 30, 30, 36) sts - place SM in first SC,

SC in the point of the V - place SM,

SC evenly along the 2nd side of the V-neck approx. 24(24, 30, 30, 30, 30, 36) sts,

Sl st evenly along edge of strap until 1st SM, sl st in 1st st to join.

Fasten off.

TIE STRAPS FINISHING

With the RS facing, insert hook at bottom of armhole, secure yarn and pull up a loop, ch 1 - place SM.

SC evenly along edge of armhole, Sl st evenly along edge of strap, place 2 sl sts in the corner st of strap, sl st across top of strap, place 2 sl sts in the corner st of strap, sl st evenly along edge of strap,

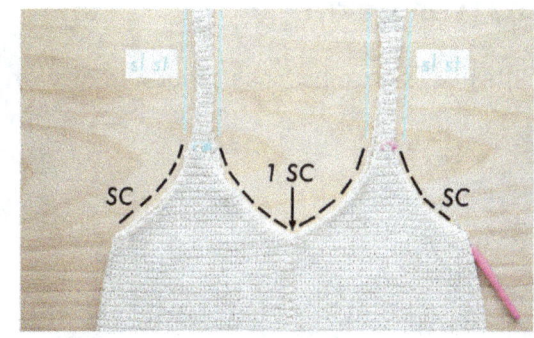

When you reach the V-neckline SC evenly along 1st side of V-neck approx. SC 24(24, 30, 30, 30, 30, 36) - place SM in first SC,

*Depending on your tension you might need to add or remove SCs.

*If you want a plain v-neck the number of stitches doesn't matter.

*If you want to add the scallop edging just make sure that the number of SCs is a multiple of 6 and crochet the same number of stitches on each side of the v-neck.SC in the point of the V - place SM.

SC evenly along the 2nd side of the V-neck approx. 24(24, 30, 30, 30, 30, 36) sts,

Sl st evenly along edge of strap, place 2 sl sts in the corner st of strap, sl st across top of strap, place 2 sl sts in the corner st of strap, sl st evenly along edge of strap,

SC evenly along edge of armhole, sl st evenly along edge of strap, place 2 sl sts in the corner st of strap, sl st across top of strap, place 2 sl sts in the corner st of strap, sl st evenly along edge of strap,

When you reach the back neckline, SC evenly along the 1st side of the V-neck approx. 24(24, 30, 30, 30, 36) sts - place SM in first SC,SC in the point of the V - place SM,

SC evenly along the 2nd side of the V-neck approx. 24(24, 30, 30, 30, 30, 36) sts,

Sl st evenly along edge of strap, place 2 sl sts in the corner st of strap, sl st across top of strap, place 2 sl sts in the corner st of strap, sl st evenly along edge of strap,

SC evenly along edge of armhole until 1st SM, sl st in 1st st to join. Fasten off.

SCALLOP EDGING

With the RS facing, insert hook in st with SM at the top of the V-neckline.

Pull up a loop, ch 1 (counts as a st),*Sk 2 sts, 7DC, sk 2 sts, sl st; rep from * until st with the SM - the last sl st should be in the st with a SM.
You should have 4(4, 5, 5, 5, 5, 6) scallops.

Rep from * until last SC - the last sl st should be in the last SC.
You should have 4(4, 5, 5, 5, 5, 6) scallops.

Fasten off.
Optional: Repeat Scallop Edging on the back v-neck of dress.
Weave in all of your ends.
Voilà! You've finished your Seascape Scallop Tank

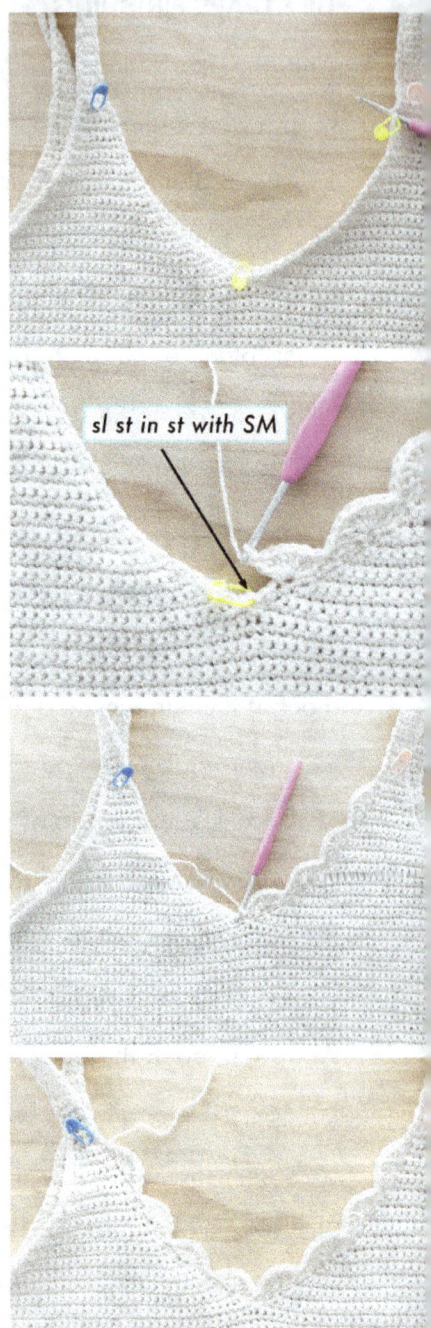

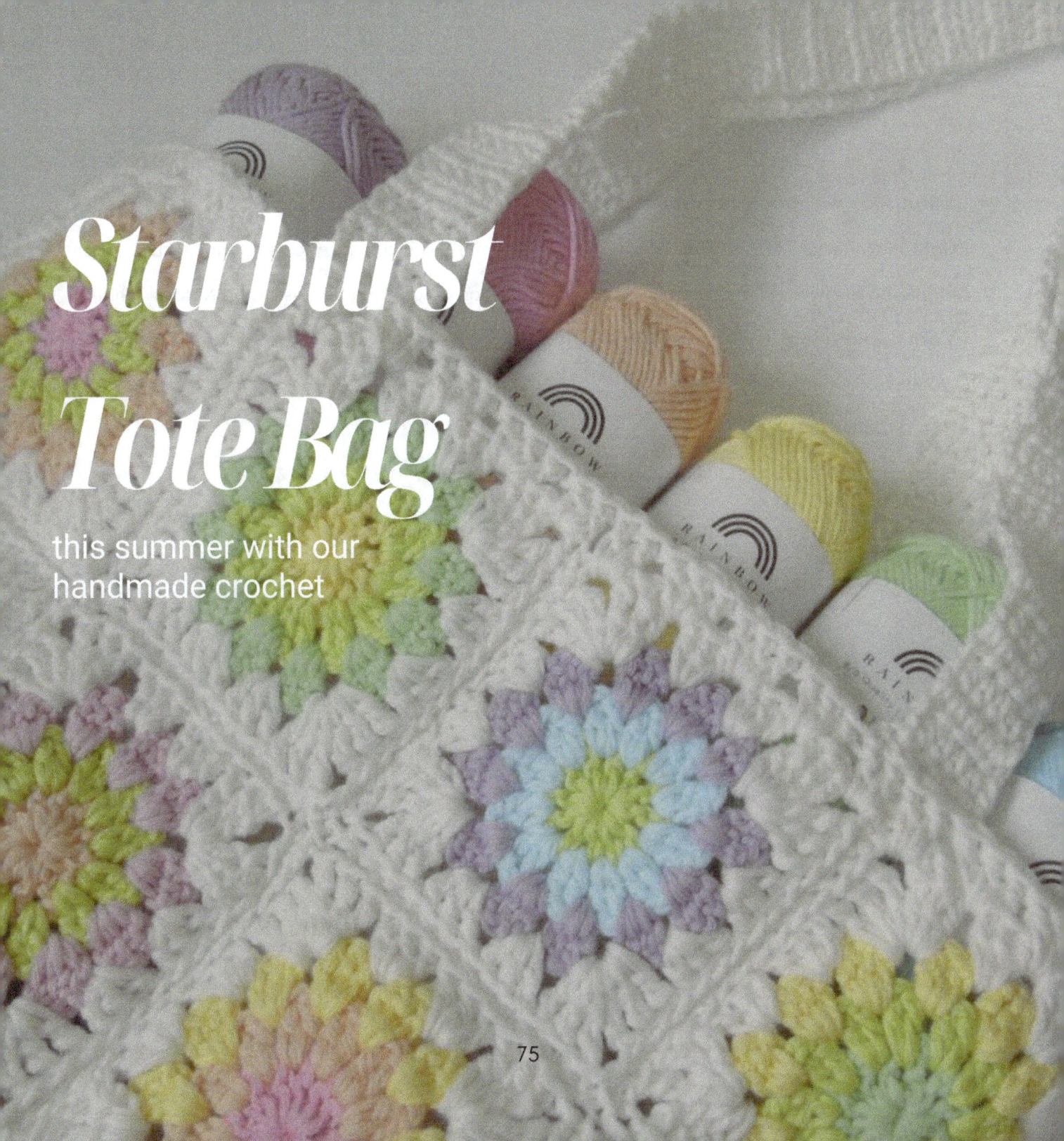

Materials

Yarn: Aran weight cotton yarn. I used Hobbii 8/8 Rainbow cotton for my bag, in the shades: Light Pink, Peach, Ochre Yellow, Lime, Light Green, Mint, Light Turquoise, Light Sky Blue, Light Purple and Natural White. You will need 1 ball of each colour and 5 balls of the Natural White.

Yarn Substitutes: You can use any 100% cotton Aran weight yarn. Paintbox Yarns Cotton Aran would work wonderfully.

Hook: 4.5mm

Others: Scissors; Darning Needle; Tape Measure

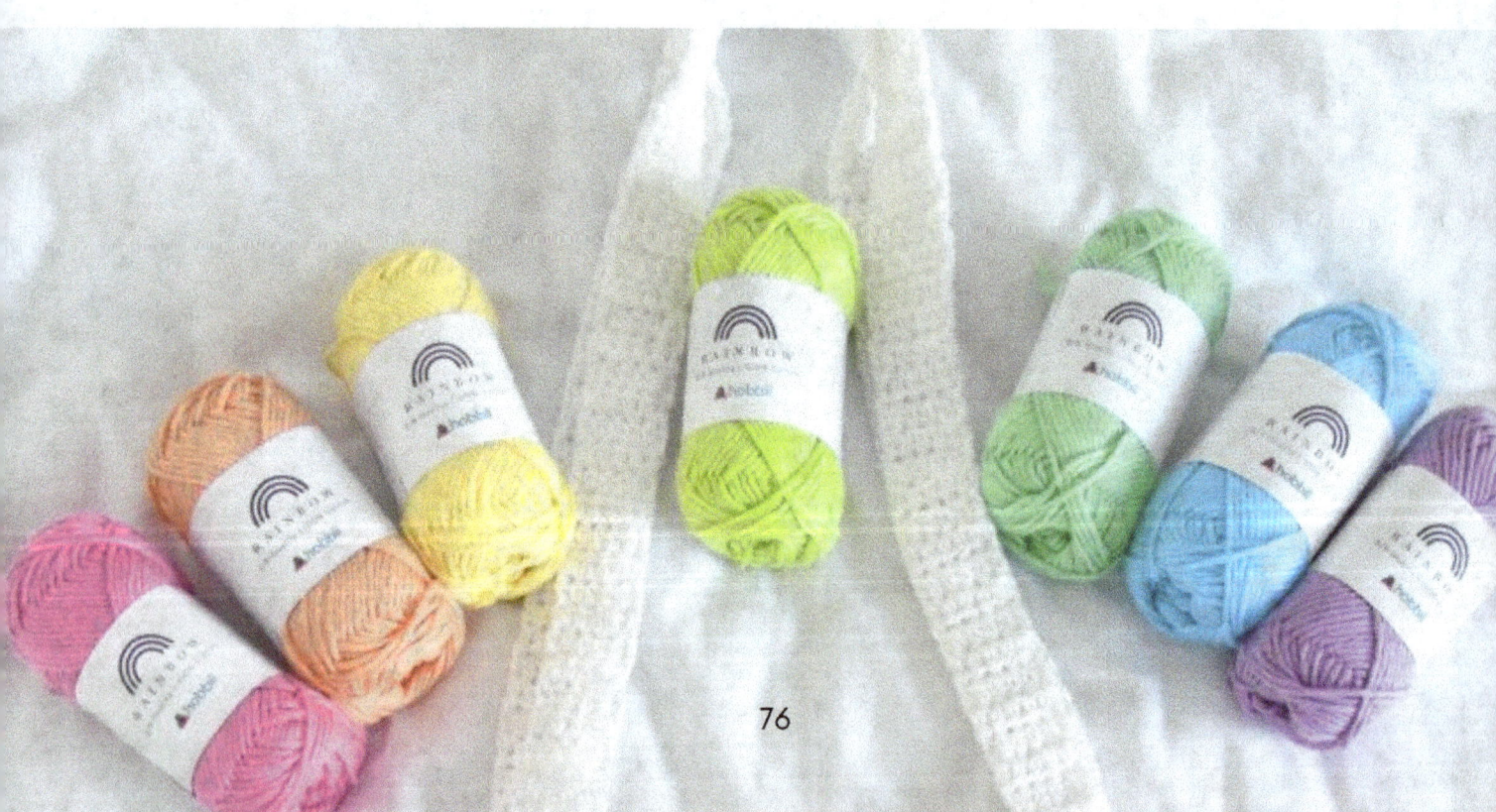

Pattern

FRONT PANEL

The front panel of the crochet tote bag is made up of 16 starburst granny squares, sewn together using the invisible seaming method.

The starburst square pattern

Round 1: In your first colour, ch4, sl st into the 4th ch from the hook to join into a circle.

Ch3 (counts as your 1st tr) and do a further 11 trs into the ring.

Sl st into the ch3 you did to begin with.

Fasten off. (You should have 12 sts in total, including the ch3)

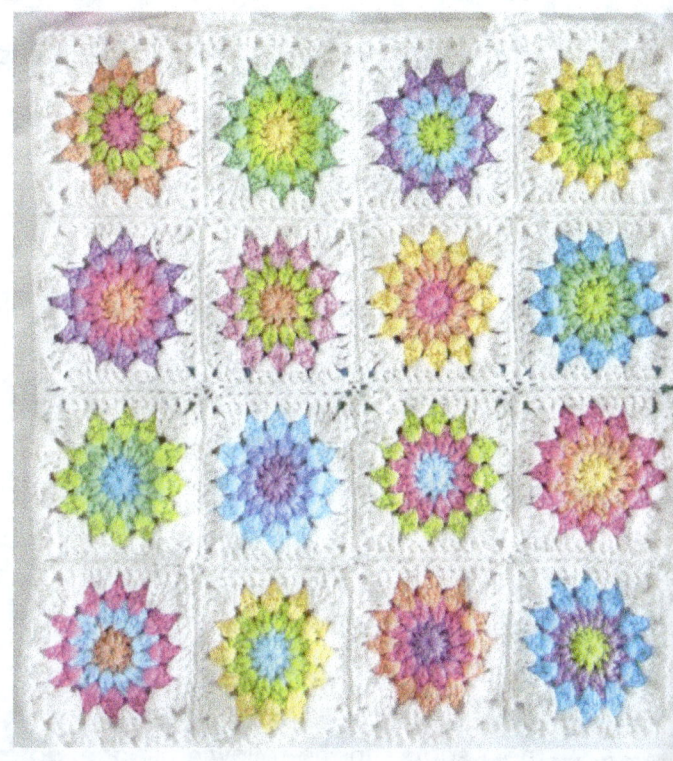

Round 2

Before starting R2, flip your circle so the wrong side is facing you. (You will flip your work like this after each round.) Then, attach your second colour in between 2 trs of the previous row. Ch3 (counts as a tr) and tr into the same space. Do 2 trs into the next gap between trs of the previous row. Keep doing this until you have 12 lots of 2 trs in each gap between the sts of R1. Finally, at the end of the round, sl st into the ch3 you did to start the round. (As a result, you should have 24 sts in total, including the ch3). Fasten off.

Round 3

Before starting R3, again flip your circle. Attach your third colour in between one of the tr clusters of the previous row. Ch3 (counts as a tr) and do 2 trs into the same space.

Then do 3trs into the next gap between the tr clusters of the previous row.

Continue doing this until you have 12 lots of 3 trs in each gap between the tr clusters of the previous round.

At the end of the round, sl st into the ch3 you did to start the round. (You should have 36 sts in total, including the ch3). Fasten off.

Round 4

Attach your base colour (Natural white) to one of the gaps between the tr clusters of the previous row. Ch4 (this counts as a st).

Do 2 dtrs, ch2, 3 dtrs into the same space. Then do 3 trs into the next space, and 3 trs into the next space. In the following space, do 3 dtrs, ch2, 3 dtrs. Do 3 trs into the next 2 spaces, then 3 dtrs, ch2, 3 dtrs.

Finally do 3 trs into the following 2 spaces, sl st into the ch4 you did to begin the round and fasten off.

You will repeat this pattern for each of the 16 starburst squares. Once you have made all 16 squares and sewn in all of the ends, you need to join them.

Adding a border

Attach your base coloured yarn (natural white) to one of the corners of the front panel.

Ch3, 2trs, ch2, 3 trs into the same space.

Do 3trs into each of the spaces between the granny clusters.

When you get to the parts where 2 of the squares have been joined, instead of doing the usual 3 trs in each gap, do 2trs (this helps make the edges neater).

At the end of this round, sl st into the ch3 you did to begin with and fasten off.

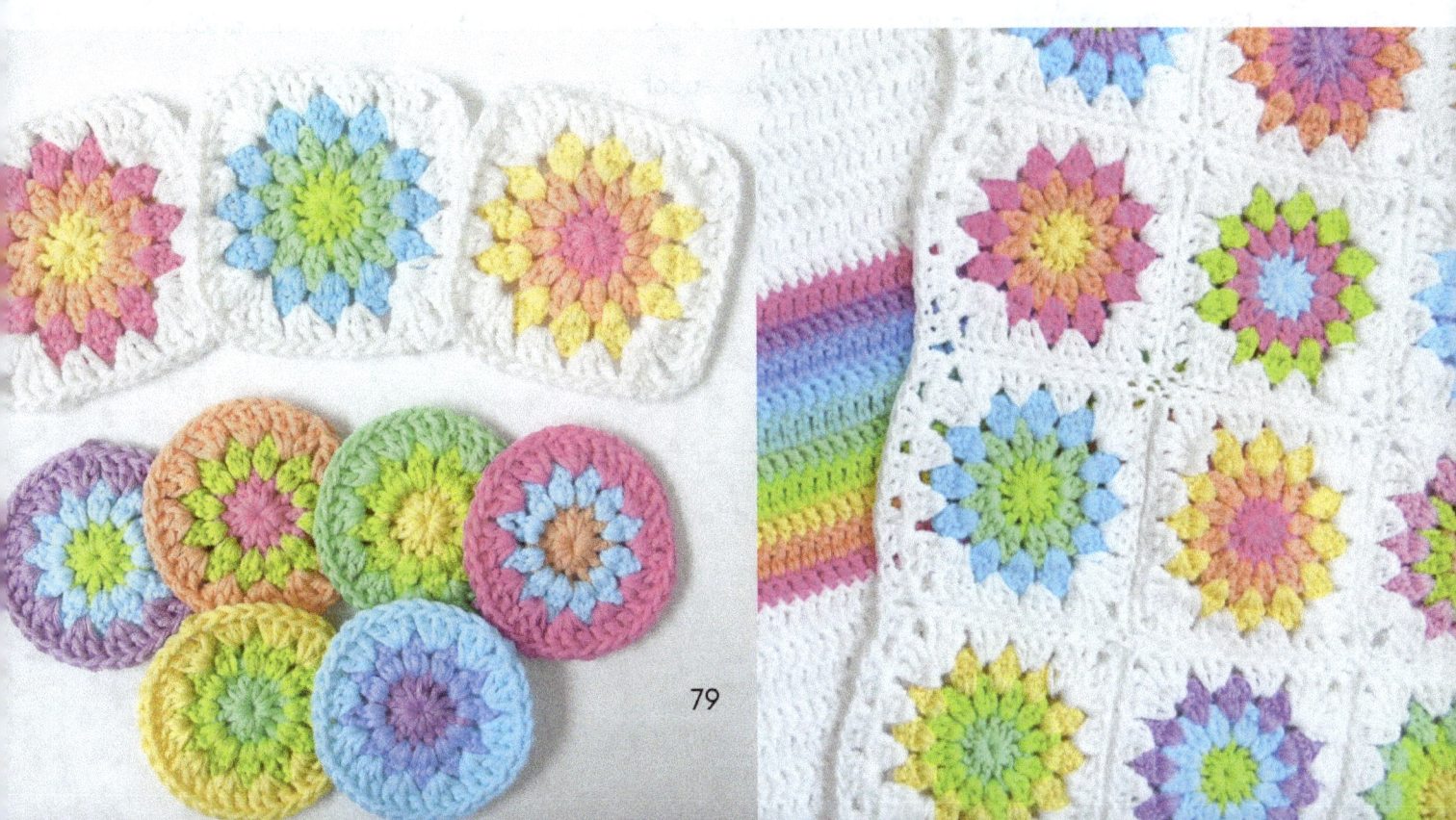

BACK PANEL

The back panel of the bag is a rectangle, made up of simple treble rows. The statement rainbow stripe across the middle adds a lovely splash of colour!

- Using the base colour (natural white) ch 62. Tr into the 3rd ch from the hook, and into each ch along. You should have 61 sts at the end of this row.
- Ch2 (counts as a st) and turn. Then, Tr into each st (61 sts). At the end of this row, ch2 and turn.
- You will carry on with this until you have done 11 rows. It is now time to add your statement stripe across the back of the bag.
- Next, attach your first colour yarn (light pink). Ch2, turn and tr in each st along (61 sts). At the end of this row, change colour to your second colour yarn (peach).
- Again, ch2 and tr in each st along the row (61 sts).
- Continue with this, changing colour after each row (the colour order I used is listed above in the materials used section).
- Once you have used all 9 colours, do a final row in the light pink. This should take you to 10 rows of colour.
- Once you have done this, change back to the base coloured yarn (natural white). Do a further 13 rows using the base colour and fasten off.

THE HANDLES

Using your base coloured yarn, ch6. Htr into the 2nd ch from the hook, and into each of the remaining 4 chs. (you should have 5 sts, not including the ch1). Ch1 (does not count as a st), turn and htr into the very first st of the row, along with the next 4 sts. (again you should have 5 sts). Keep doing this until you have done 73 rows, or until the handles are your desired length (For mine 73 rows = 27 inches). Once you have completed your first handle, repeat the exact same thing for your second handle.

ASSEMBLING THE BAG

Place your front and back panels together, right sides facing. They should be the same size. (If they are slightly different sizes it would be a good idea to block both panels to make them the same size). Sew them together along 3 of the sides (again the invisible joining method is a good one to use), leaving one side unsewn (this will be the top of your bag).
You will attach your handles to what will be the inside of your bag. Place the handles so that there is about an inch of overlap between the ends of the handle and the top of the bag and sew them together. It is important to make sure the handles are sewn on securely.

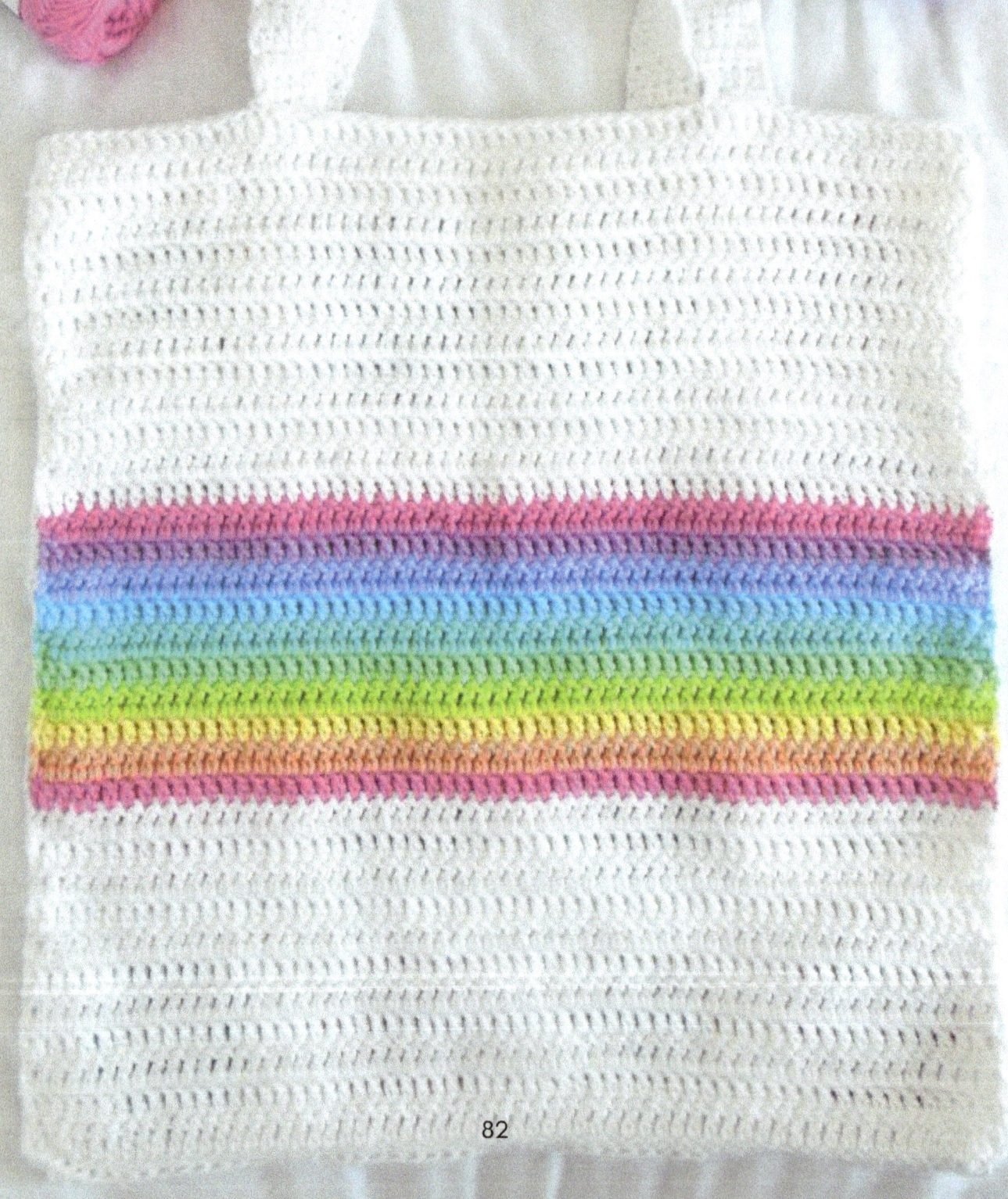

Raffia Summer Bag

MATERIALS

Yarn:

4 x King Cole Raffia - in the color Natural - (1456) 100g

Alternative raffia yarn - Ra Ra Raffia from Wool and The Gang

Crochet Hook: 8 mm (US L/11)

Notions:

Scissors.

Darning needle.

Tape measure.

Closed stitch markers

Other Materials

Thread or cord for the tassel.

Keyring clip x 1 for the tassel - 1.5 inch/ring - 1 inch

Keyring clips x 2 for the bag chain - 1 inch

Gold bag chain - 43 inches

Pliers

Tassels

Make 3-6+ tassels from leftover yarns.

The tassels will be tied together on a keyring to hang from one handle on the bag.

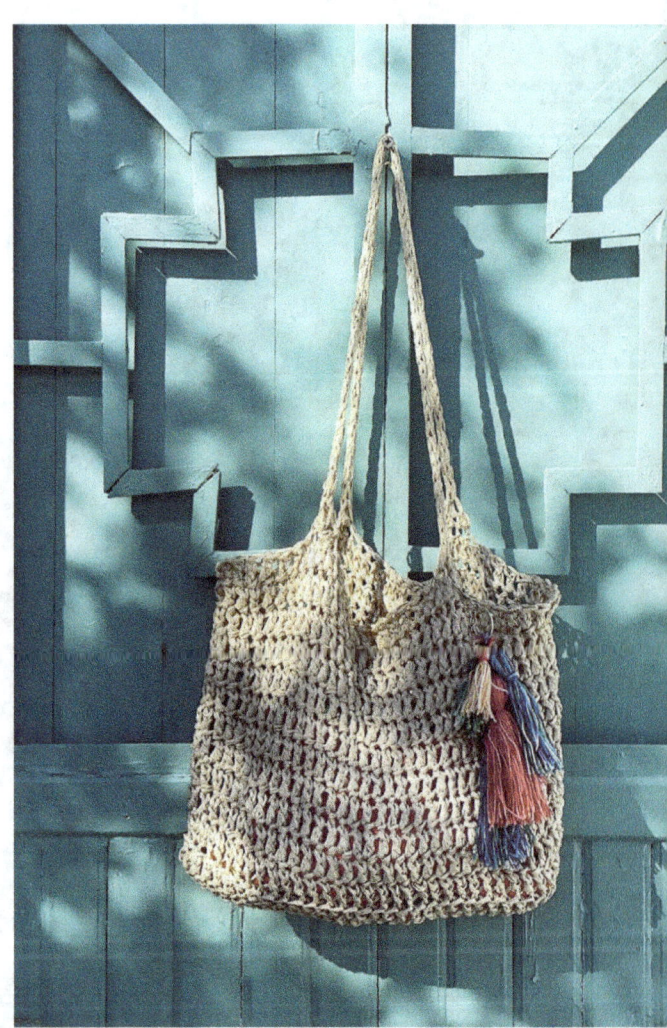

PATTERN NOTES

- For the base – Do not turn at the end of the round, but continue working in a spiral, with the right side (RS) always facing.
- Keep count of the sts by placing a marker (PM) on the last st of each round.
- There are no turning chains in this pattern.
- The bag is worked using two strands of raffia held together.

PATTERN

The Base Of The Bag

ch 30

Round 1: dc into the second ch from the hook, dc into every ch until the end. dc twice more in the final ch (3 dc's in total in the final ch). Place a closed st marker in the center of the 3 sts. Turn the work and dc into every ch on the other side. dc 3 times in the final st. Mark the center of the 3 sts with a closed st marker.

Round 2: dc into every st until one st before the marker, 2 dc in next st, remove marker, 3 dc in the next st, 2dc in the next st. Replace the marker in the center st of the 3 st increase. rep to finish the other side of the base.

Rep round 2 once more.

Your base should measure 15 inches in length and 5.5 inches in width.

There should be 6 rounds of double crochet in the finished base.

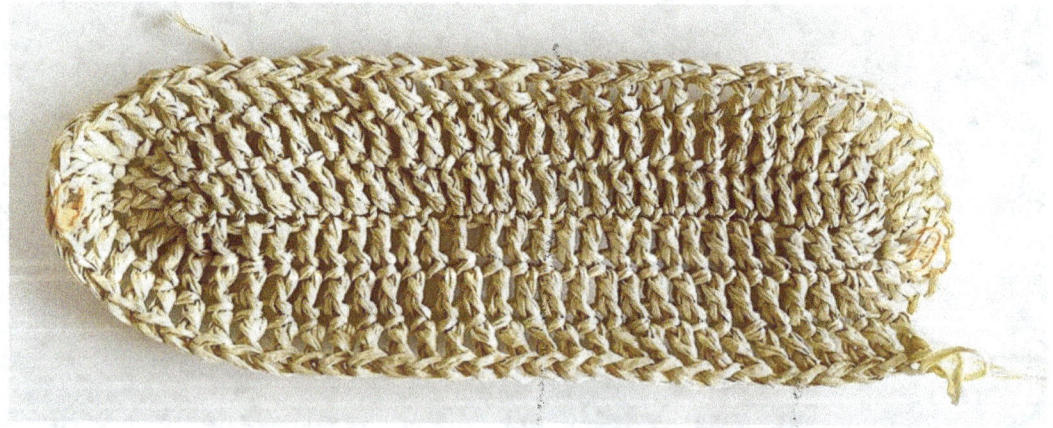

The Body Of The Bag

Next Round - dc into all the sts into the back loop only.

Please note - place a marker to denote which is the beginning/end of the round.

Continue to work in a spiral - dc all of the sts in every round (in both loops) - until the bag measures = 10 inches (rounds worked- 11). You can make the bag taller - need more raffia.

Finish the last st with an ss and cut the yarn, leaving a short length of about 3 inches.

Secure and weave in the ends.

Weave in all other loose ends.

The Bag Handles

The bag handles are worked using two strands of raffia together.

Join the raffia 9 sts in from the side of the bag, and pull up a loop in each of the next 3 sts to work an I-cord.

I-cord written instructions: Starting with 3 loops as instructed, *pull up a loop through the second ch from hook and third ch from hook (3 loops on hook), slip these 2 loops onto a knitting or cable needle, 1 ch, (slip 1 loop from needle back onto the hook, 1 ch) twice. Rep from * until I-cord is your desired length.

The I-cord handles are around 28 inches long / 49 rows worked.

Miss the next 13 sts, join the end of the I-cord to the next 3 sts (crochet and attach to the bag to match the other strap from the front).

Rep for the other side of the bag.

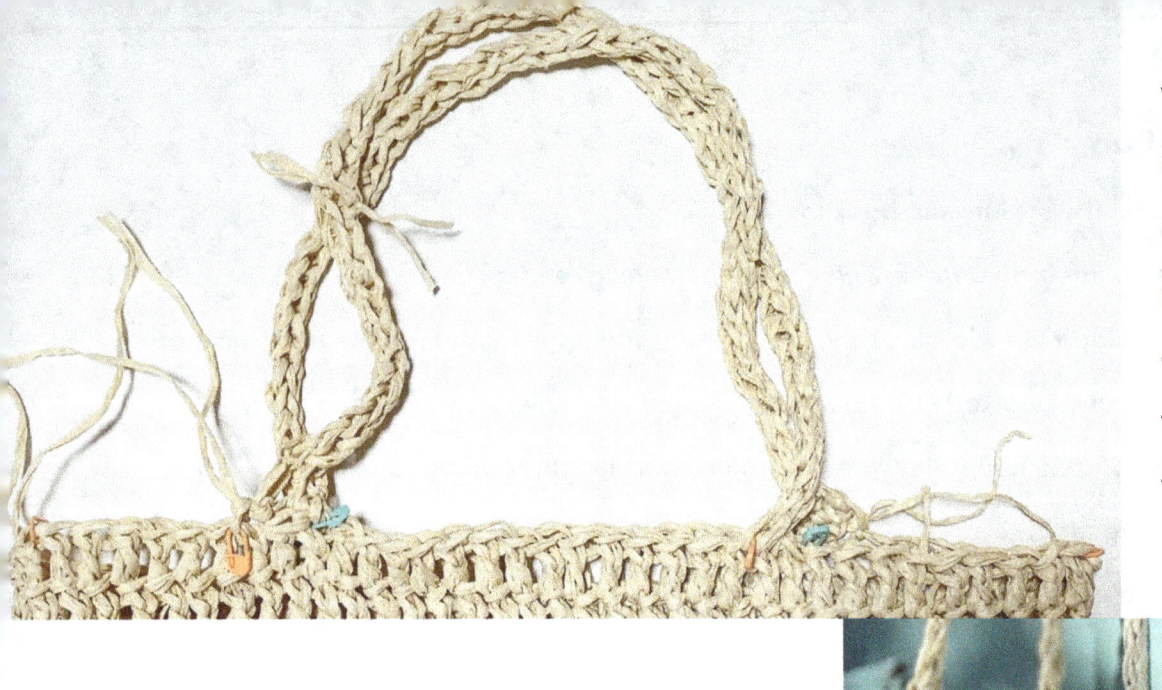

You can see in the image where closed markers have been placed to make it easier to count out the sts needed for the bag handles.

Tassel Charm

You may wish to add a tassel charm from leftover yarns in your stash.

For this, you will need a keyring clip with a ring, so that you can tie the tassels onto the ring.

The keyring clip can then be clipped to the bag, to one of the handles, or wherever you like.

Alternatively, you may want to tie a colorful scarf or leave the bag as it is!

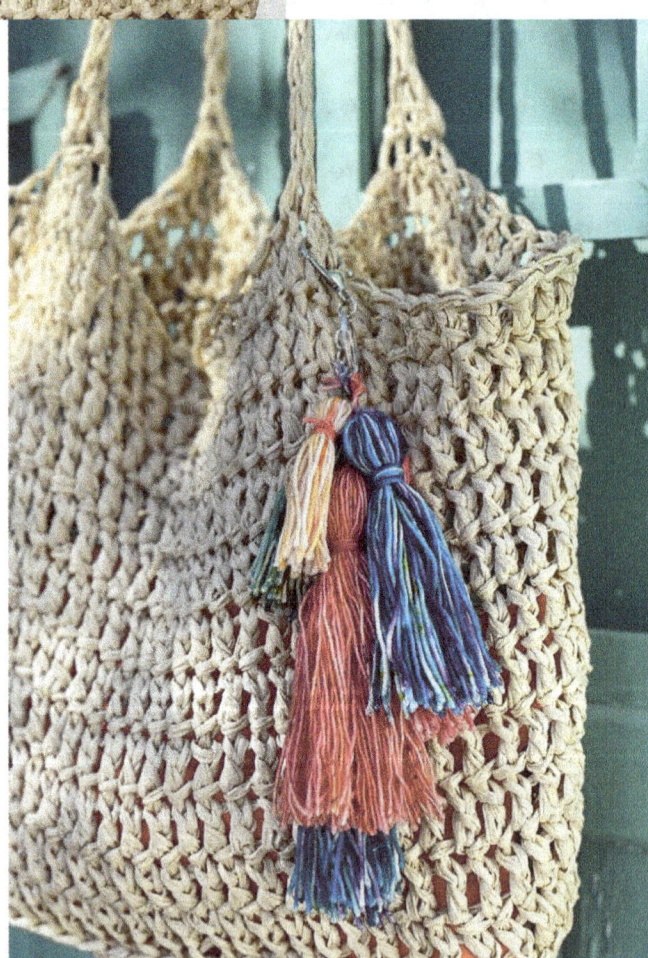

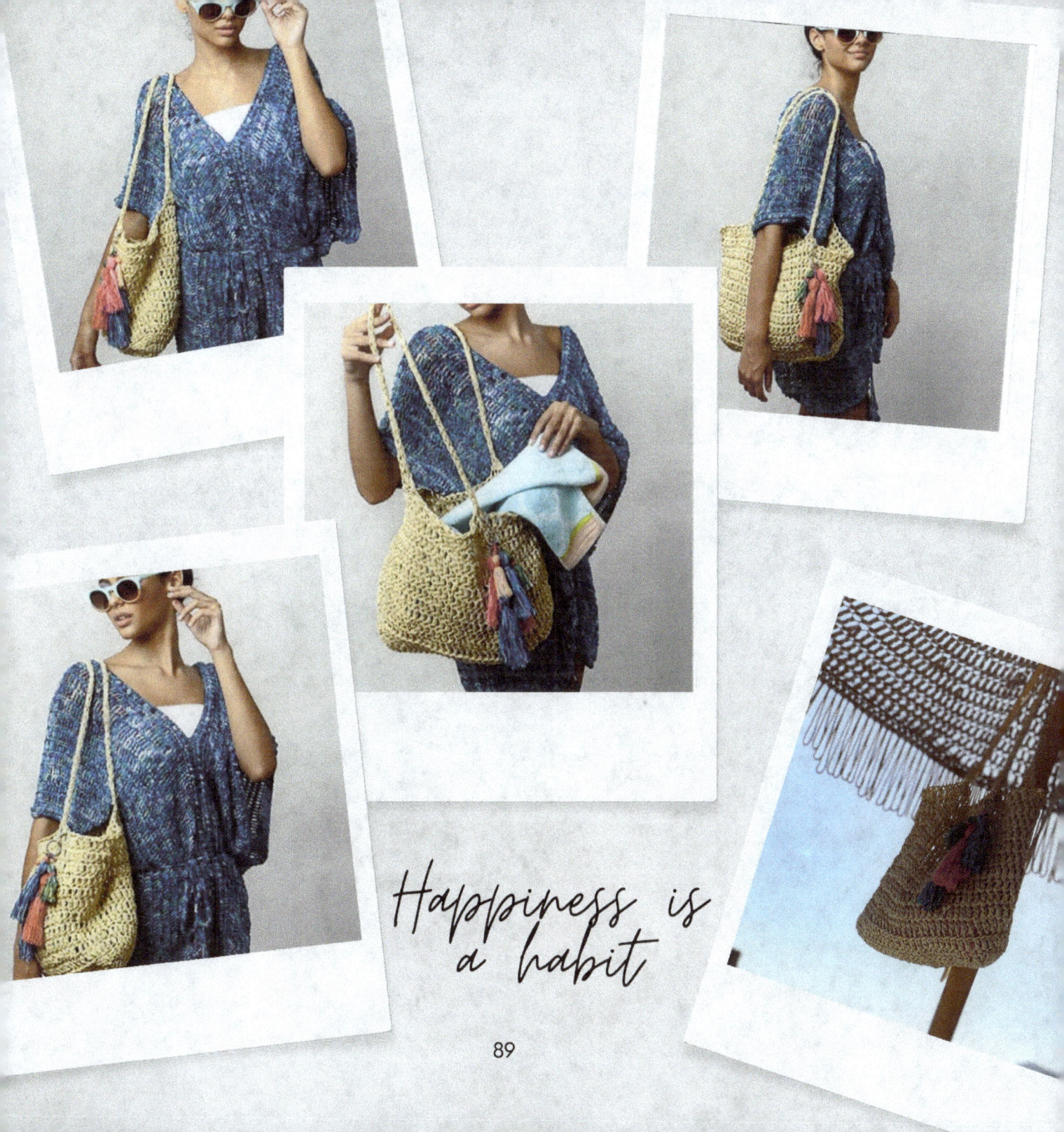

Happiness is a habit

Granny Square Bucket Hat

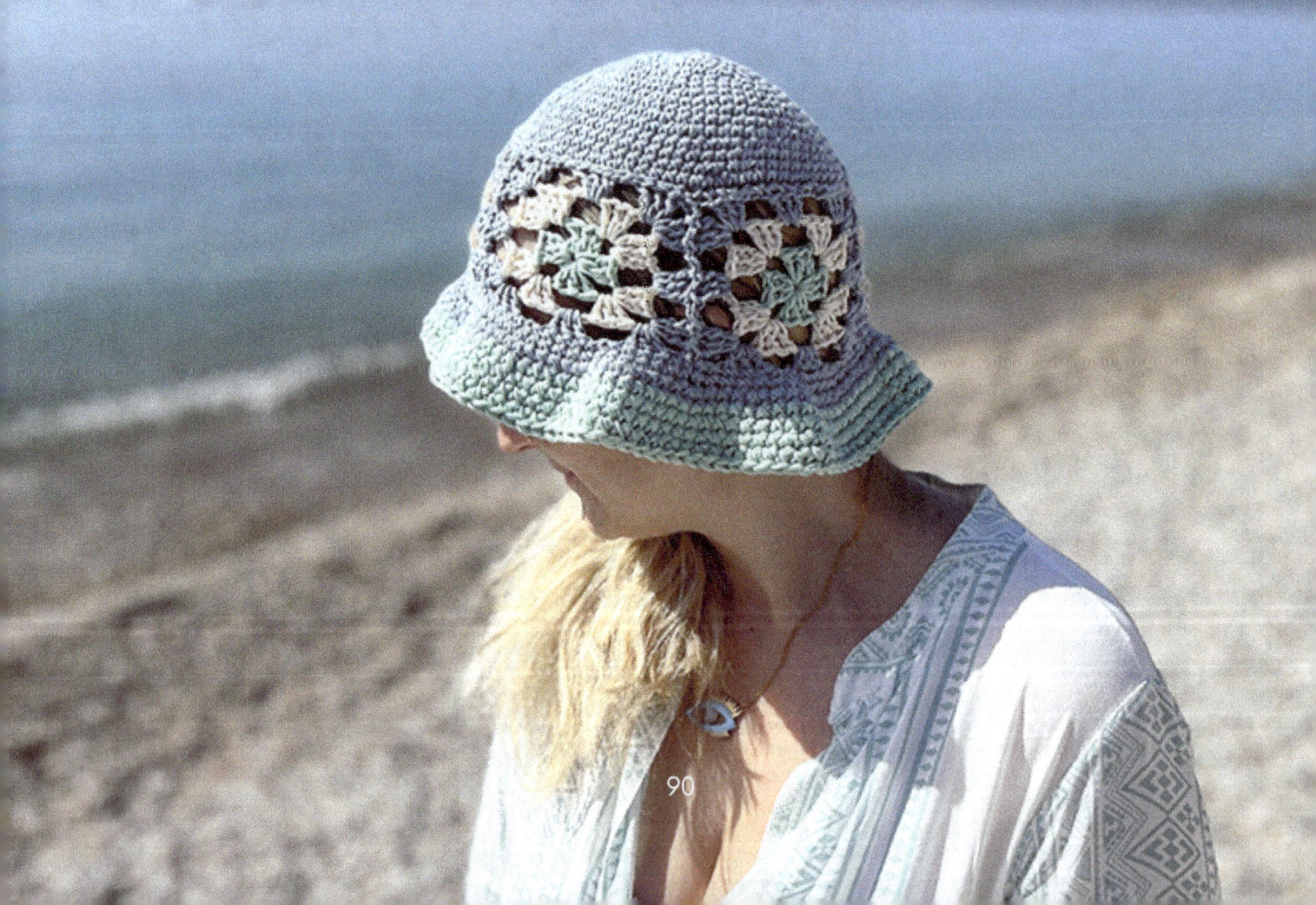

Materials

Yarn: We Are Knitters - The Cotton in the color Denim, Natural and Mint. This cotton is 100% Pima Cotton/10g/3.05oz/232 yds/212m.

Hook: 5 mm (US H-8) Crochet hook

Notions:

- Scissors
- Darning needle/tapestry needle
- Tape measure
- Stitch markers

PATTERN NOTES

- This granny square bucket hat uses one hook size only.
- There are no turning chains, the hat is worked in a spiral.
- You can use stitch markers to denote the beg and end of a round.

Pattern

Granny Square Pattern

Color 1 - Mint; Color 2 - Natural; Color 3 - Denim

Make 5 Granny squares.

With the first color, ch 4, sl-st in the first ch to form a ring.

Round 1: Ch 3, 2 dc in the ring, (ch 3, 3 dc in ring) 3 times, ch 3, join with a sl-st in top of first ch 3, fasten off.

Round 2: Join 2nd color in any corner 3 ch-sp, ch 3, 2 dc in same sp, ch 3, 3 dc in same sp, ch 3, (3 dc, ch 3, 3 dc in next sp, ch 3) 3 times, then join with a sl-st in top of first ch 3, fasten off.

Round 3: Join 3rd color in any corner 3 ch-sp, ch 3, 2 dc in same sp, ch 3, 3 dc in same sp, ch 3, (3 dc in next space between 3 dc groups, ch 3, 3 dc, ch 3, 3 dc in next 3 ch-sp) 3 times, 3 dc in next sp between 3-dc groups, ch 3, join with a sl-st in top of first ch 3, fasten off.

Weave in all ends.

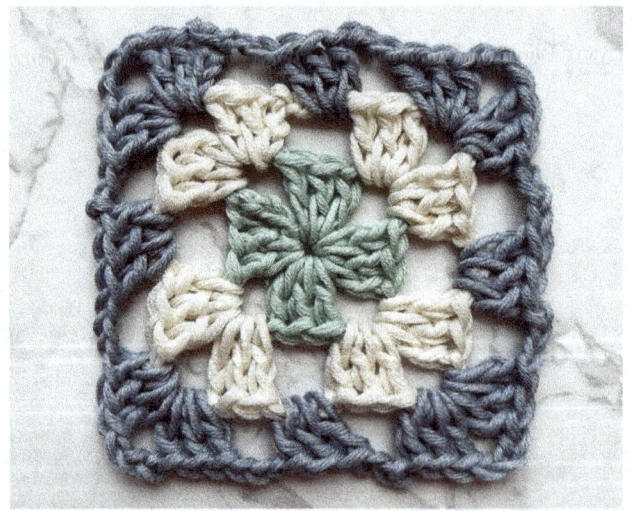

Bucket Hat Pattern

In Color 3 - Denim

With the 5 mm (US H/8) Crochet hook ch 2.

(Please note, rounds 1-17 are worked on the right side in a spiral.)

Round 1 : Work 10 sc in 2nd ch from hook.

Please note: Keep track of where your rows start by placing a stitch marker on the last st of each round. There are no turning chains in the pattern.

Round 2: 2 sc in each sc.

Round 3: *sc in each of next 3 sc, 2 sc in next sc (inc made), rep from * around. (25 sc)

Round 4: *sc in each of next 4 sc, 2 sc in next sc (inc made), rep from * around. (30 sc)

Round 5: *sc in each of next 5 sc, 2 sc in next sc (inc made), rep from * around. (35 sc)

Round 6: *sc in each of next 6 sc, 2 sc in next sc (inc made), rep from * around. (40 sc)

Round 7: *sc in each of next 7 sc, 2 sc in next sc (inc made), rep from * around. (45 sc)

Round 8: *sc in each of next 8 sc, 2 sc in next sc (inc made), rep from * around. (50 sc)

Round 9: *sc in each of next 9 sc, 2 sc in next sc (inc made), rep from * around. (55 sc)

Round 10: *sc in each of next 10 sc, 2 sc in next sc (inc made), rep from * around. (60 sc)

Rounds 11 and 12: sc in each sc around.

Round 13: *sc in each of next 14 sc, 2 sc in next sc (inc made), rep from * around. (64 sc)

Round 14: sc in each sc around.

sl-st and fasten off.

Attach The Granny Squares

Next, you will seam the granny squares to the hat.

Start by cutting a length of yarn, threading your darning needle, and then attaching the first granny square to the edge of the hat with the right sides facing you. Seam through the top loops only.

When all of the granny squares have been seamed to the crown/top of the hat, you will then need to seam the granny square edges to each other. They will also have to be seamed through the top loops only.

Once you have completed that, you can then continue to work in Color 3 - Denim. Push the crochet hook through a ch in one of the granny squares and pull the yarn through, then work rounds of sc until the hat measures 18 cm/7 inches from the top of the hat.

Try it on to see if it is long enough to cover your head; you could add rounds to make it a little longer if you wish.

The Brim

Changed to Color 1.

All of the following rounds are worked on the right side in a spiral.

Use 2 strands of yarn together to continue...

Round 1: *sc in each of the next 3 sc, 2 sc in next sc (inc made) rep from * around. (80 sc)

Rounds 2-8: sc in each sc around.

The brim should measure 5 cm/2 inches from the beg of the brim.

To finish off, join with a sl-st into the beg sc of the round.

Cut yarn and weave in any loose ends.

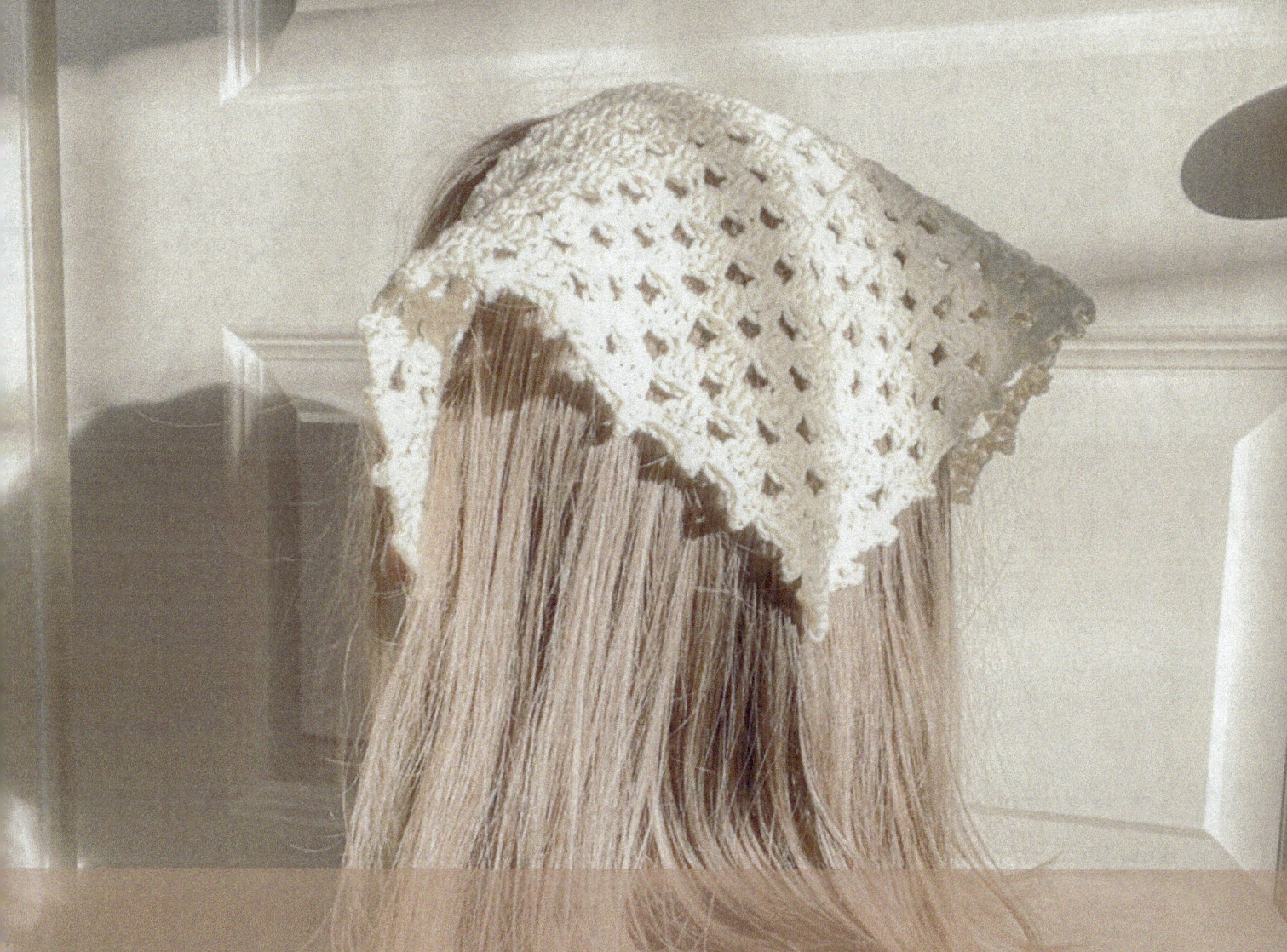

Summer Breeze Bandana

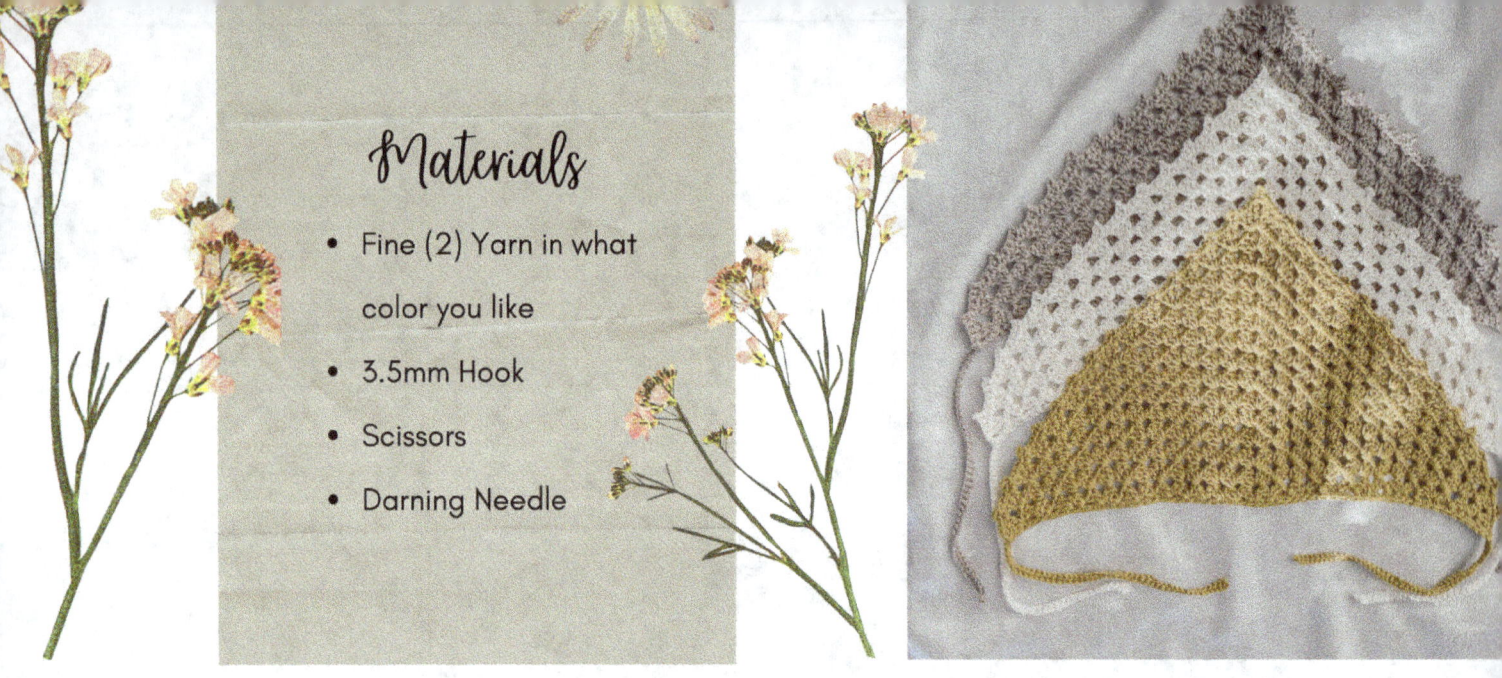

Materials

- Fine (2) Yarn in what color you like
- 3.5mm Hook
- Scissors
- Darning Needle

Pattern

Create a Magic Ring.

Row 1: Ch 3 (the first ch 3 of every row counts as a double crochet stitch), work 2 dc into the ring, ch 3, work 3 more dc into the ring. close your magic ring.

Row 2: Turn your work. Ch 3, work 2 dc into first st, ch 1, work 3 dc in top corner ch space, ch 3, work 3 dc in same top corner ch space, ch 1, work 3 dc in last st of the row.

Row 3: Turn your work. Ch 3, work 2 dc into first st, ch 1, work 3 dc in ch space, ch 1, work 3 dc in top corner ch space, ch 3, work 3 dc in same top corner ch space, ch 1, work 3 dc into ch space, ch 1, work 3 dc into last st of the row.

Row 4: Turn your work. Ch 3, work 2 dc into first st, ch 1, work 3 dc into ch space, ch 1, work 3 dc into ch space, ch 1, work 3 dc into top corner ch space, ch 3, work 3 dc into same top corner ch space, ch 1, work 3 dc into ch space, ch 1, work 3 dc into ch space, ch 1, work 3 dc into last st of the row.

Row 5-15: You will repeat the same process for every row of- Turn your work. 3 dc into first st (ch 3 counts as 1 of the 3 dc in the first st), 3 dc in every ch space with a ch 1 in between each dc cluster, 2 dc clusters in the top corner ch space with a ch 3 to separate the two clusters, and 3 double crochet in the last st of the row. Just keep repeating this pattern until you have 15 rows (or how ever many you want or need for the size head you're making it for).

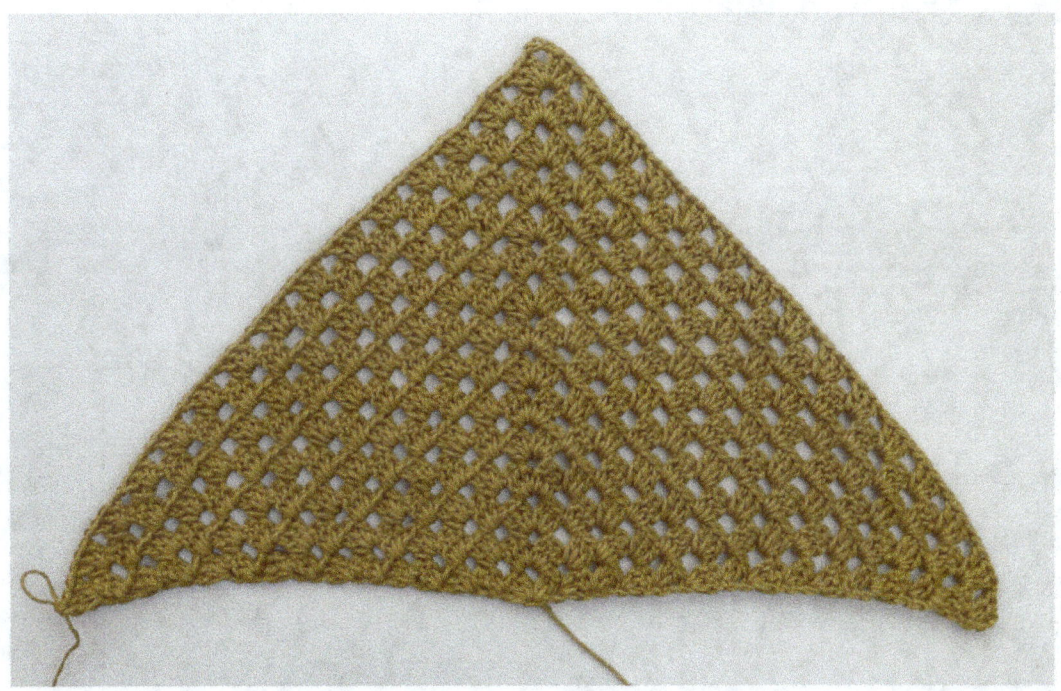

How it should look after 15 rows

Picot Edging

After you have your 15 rows (or how ever many rows you made), we will now be working on the Picot Edging (if you do not care for this part, this step can easily be skipped).

Row 1: Turn your work. Ch 1 (ch 1 does not count as a st), sc 3, ch 3, sl st into the 3rd ch from the hook, sc 4 (with one of those 4 sc being worked into the ch space), *ch 3, sl st into the 3rd ch from your hook, sc 4, *repeat until you come to the top corner ch space.

When you come the the top corner ch space, work 1 sc in ch space, ch 3, sl st into the 3rd ch from the hook, sc 4 (with 1 of those 4 sc being worked into the top corner ch space), *ch 3, sl st into the 3rd ch from the hook, sc 4, *repeat until you have 3 sts left. Sc in last 3 remaining sts.

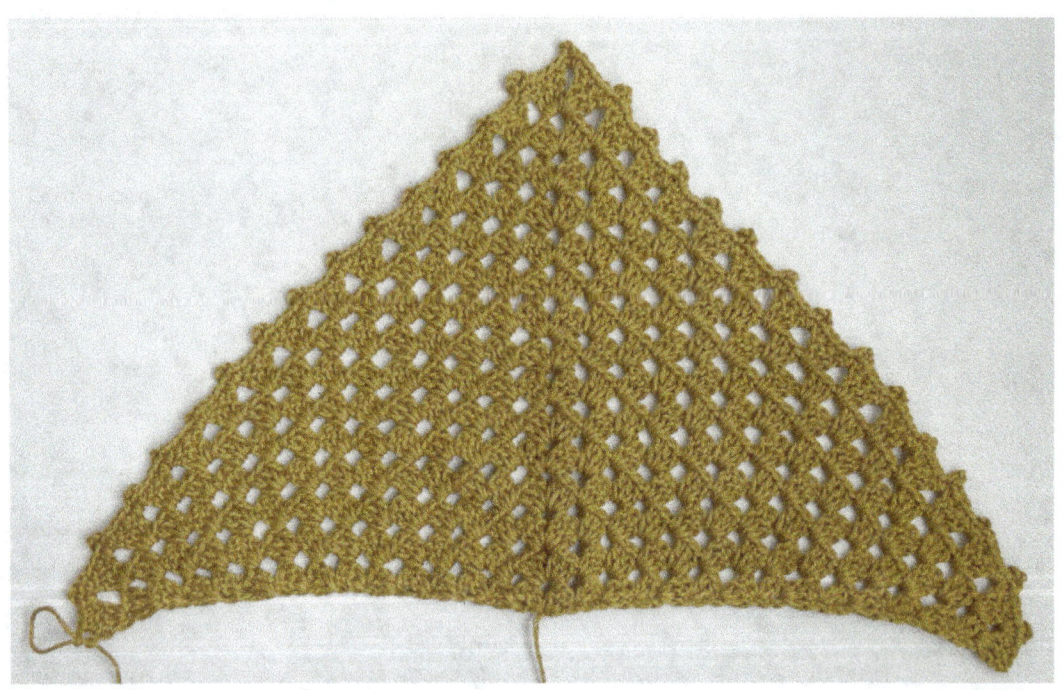

With the picot edging

Ties

Still being attached to your work (do not fasten off).

Ch 46. Sl st in the 2nd ch from the hook, sl st into each ch until the end of the ch.

Sc crochet across the bottom of the bandana (there is no set number you need to sc across, just enough to make it to the opposite edge of the bandana)

Ch 46. Sl st in the 2nd ch from the hook, sl st into each ch until the end of the ch. Work 1 sl st in to the main body of the bandana to help better secure the tie bandana.

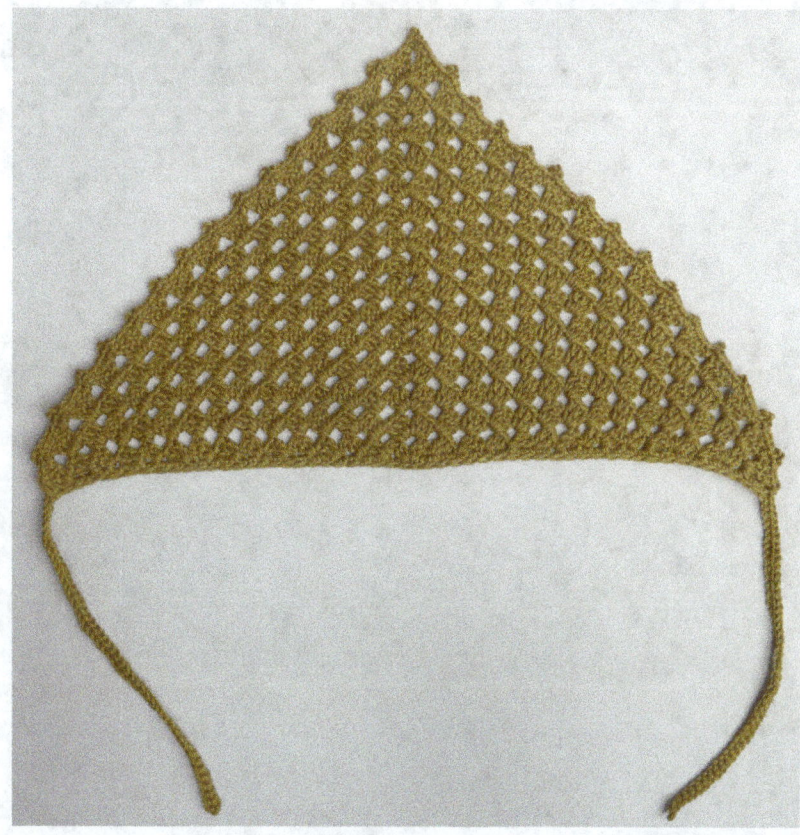

With the ties

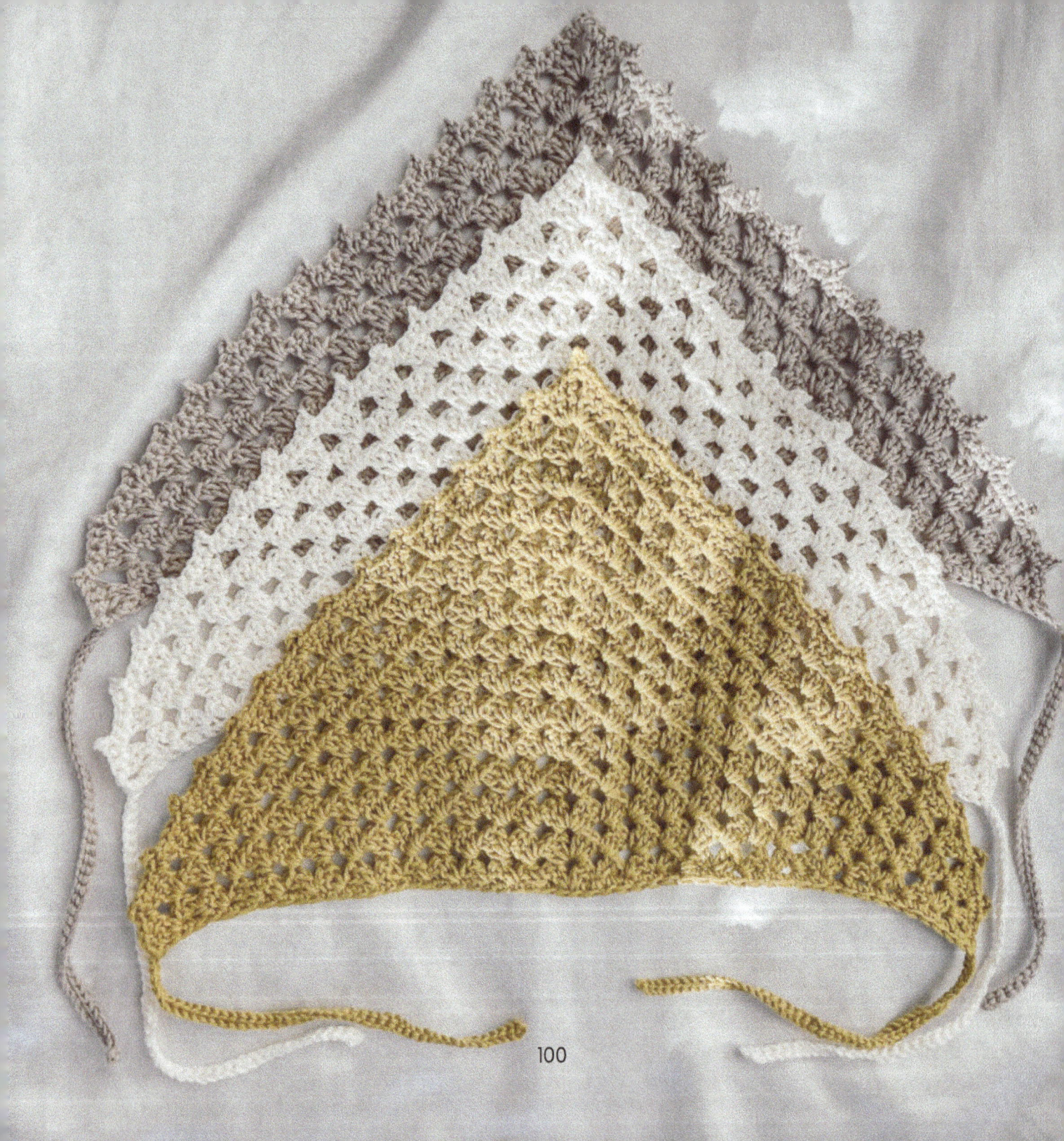

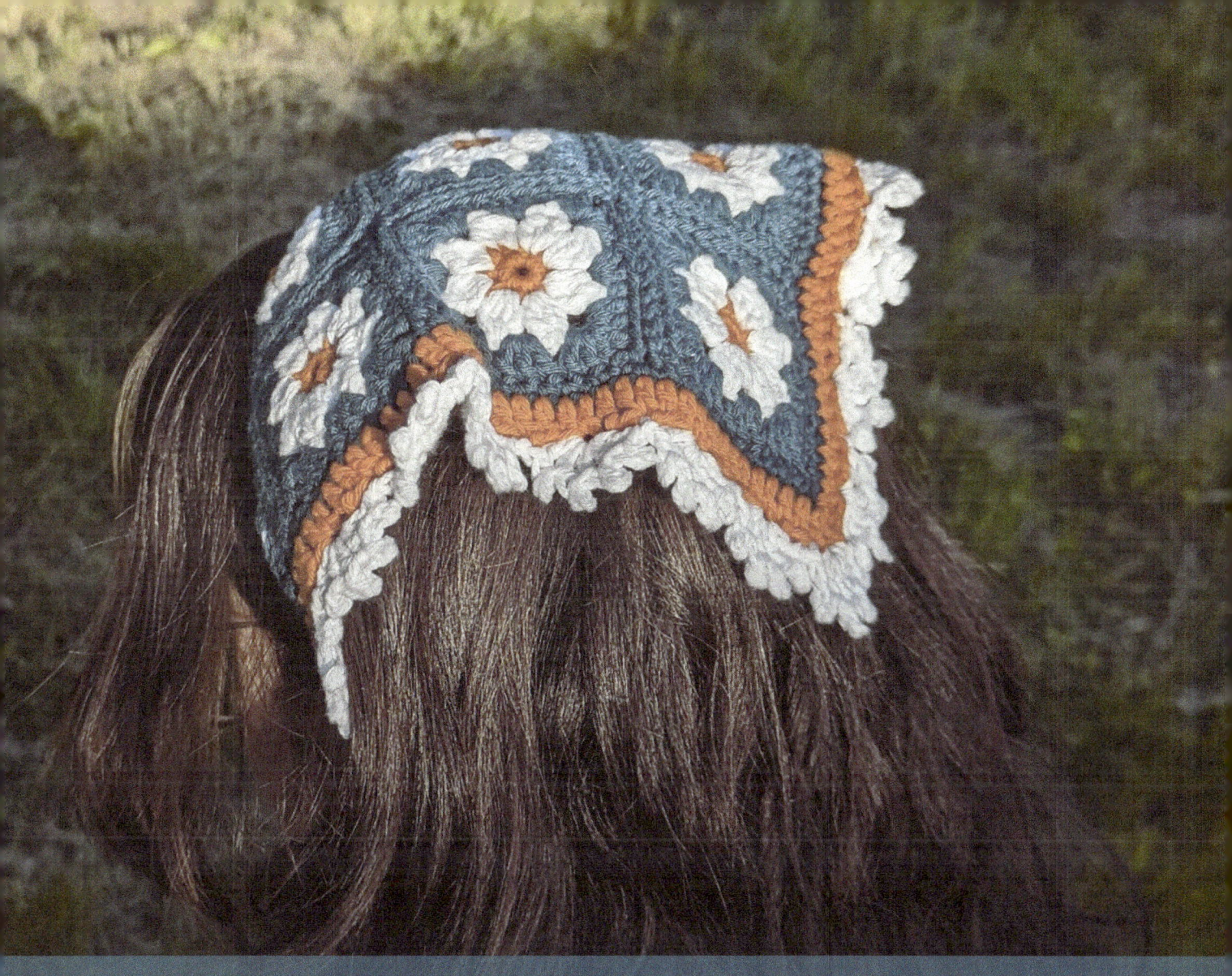

Oopsy Daisy Bandana

MATERIALS

YARN: Hobbii Yarns Friends Cotton 8/6 (DK weight, 100% cotton); 115 yds (105 m)/50 g

Whisky (16) 1 ball (Colour A)

White (01) 1 ball (Colour B)

Deep Ocean (89) 1 ball (Colour C)

CROCHET HOOK: Size US G/6 (4 mm) crochet hook

OTHER: Tapestry needle

GAUGE

1 granny square = 2.5 in/6 cm Finished Dimensions

A) Depth = 8.5 in/22 cm

B) Width 15 in/37 cm

C) Width with ties = 42 in/107 cm

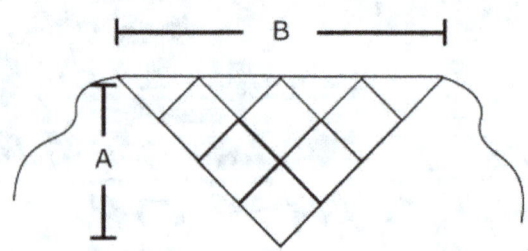

PATTERN

SQUARES (MAKE 6)

Make a magic ring using Colour A, ch 2.

Rnd 1: 8 sc into magic ring. Join last sc to first sc with a sl st and fasten off. (8 sc)

Rnd 2: with Colour B, join in any sc and ch 3 (counts as a dc). Beg-cl st in the same sc, ch2. *Cl st, ch 2* in each remaining sc. Join with a sl st to starting ch 3 and fasten off. (8 petal clusters)

Rnd 3: with Colour C, join in any ch-2 sp and ch 5. 3 dc in the same starting sp. 3 dc in next ch-2 sp. *3 dc, ch2, 3 dc in next ch-2 sp. 3 dc in next ch-2 sp* 3 times. 3 dc in first sp and join to 3rd st in starting ch-5 and fasten off. (36 dc, 4 ch-2 sp)

TRIANGLES (MAKE 4)

Note that I choose to work every row on the RS. (start rnd 2 where you started rnd 1, and so on)

Make a magic ring using Colour A, ch 2.

Rnd 1: 4 sc into magic ring. Fasten off. (4 sc)

Rnd 2: with Colour B, join in first single crochet and ch 3 (counts as a dc). Beg-cl st in the same sc, ch2. *Cl st, ch 2* in next 2 sc. Cl st in last sc, ch 1 and fasten off. (4 petal clusters)

Rnd 3: with Colour C, join in first petal cluster and ch 3, 2 dc. 3 dc in next ch-2 sp. 3 dc, ch 2, 3 dc in next ch-2 sp. 3 dc in next ch-2 sp. 3 dc in ch-1 from end of Rnd 2 and fasten off. (18 dc, 1 ch-2 sp)

Weave in ends and join the squares and triangles together according to dia- gram on first page. (I prefer to join granny squares using the slip stitch method, but you can use whatever method you want as long as it doesn't add too much bulk between the squares)

BORDER:

Again, I'm working only on the RS for every rnd.

Rnd 1: with RS facing up, join in top left corner with Colour C. Ch 2 (counts as a sc) and then Crochet 45 sc evenly along this edge. Sc, ch 2, sc in the ch-2 sp of the granny square at the bottom point of the bandana. Crochet 46 sc evenly along next edge and fasten off. (94 sc, 1 ch-2 sp)

Rnd 2: with Colour A, join in starting ch-2 and ch 3. Dc in each sc along this edge. Dc, ch 2, dc in ch-2 sp. Dc in rest of sc along next edge. Fasten off. (96 dc, 1 ch-2 sp) Rnd 3: with Colour B, join in starting ch-3 and ch 1. Sk next dc. In next dc, (*dc, picot* 4 times, dc). *Sk 2, sl st in next dc, sk 2, (**dc, picot** 4 times, dc) in next dc* 7 times along this edge. Sk 2, sl st in next dc. In ch-2 sp, (*dc, picot* 4 times, dc). Sl st in next dc, sk 2, (*dc, picot* 4 times, dc). *Sk 2, sl st in next dc, sk 2, (**dc, picot** 4 times, dc) in next dc 7 times along next edge. Sk 1, sl st in last dc. Fasten off. (85 dc, 68 picots, 18 sl st)

TIES:

With RS facing up, join in sl st from rnd 3 of border with Colour C. Ch 52. Sc in 2nd ch from hook and sc across in each ch until you reach the starting ch. Crochet 60 sc evenly along the top edge. Ch 52. sc in 2nd ch from hook and sc across in each ch. Join to last sc on top edge with a sl st. Fasten off

FINISHING

Weave in all ends and don't forget to block your work :)

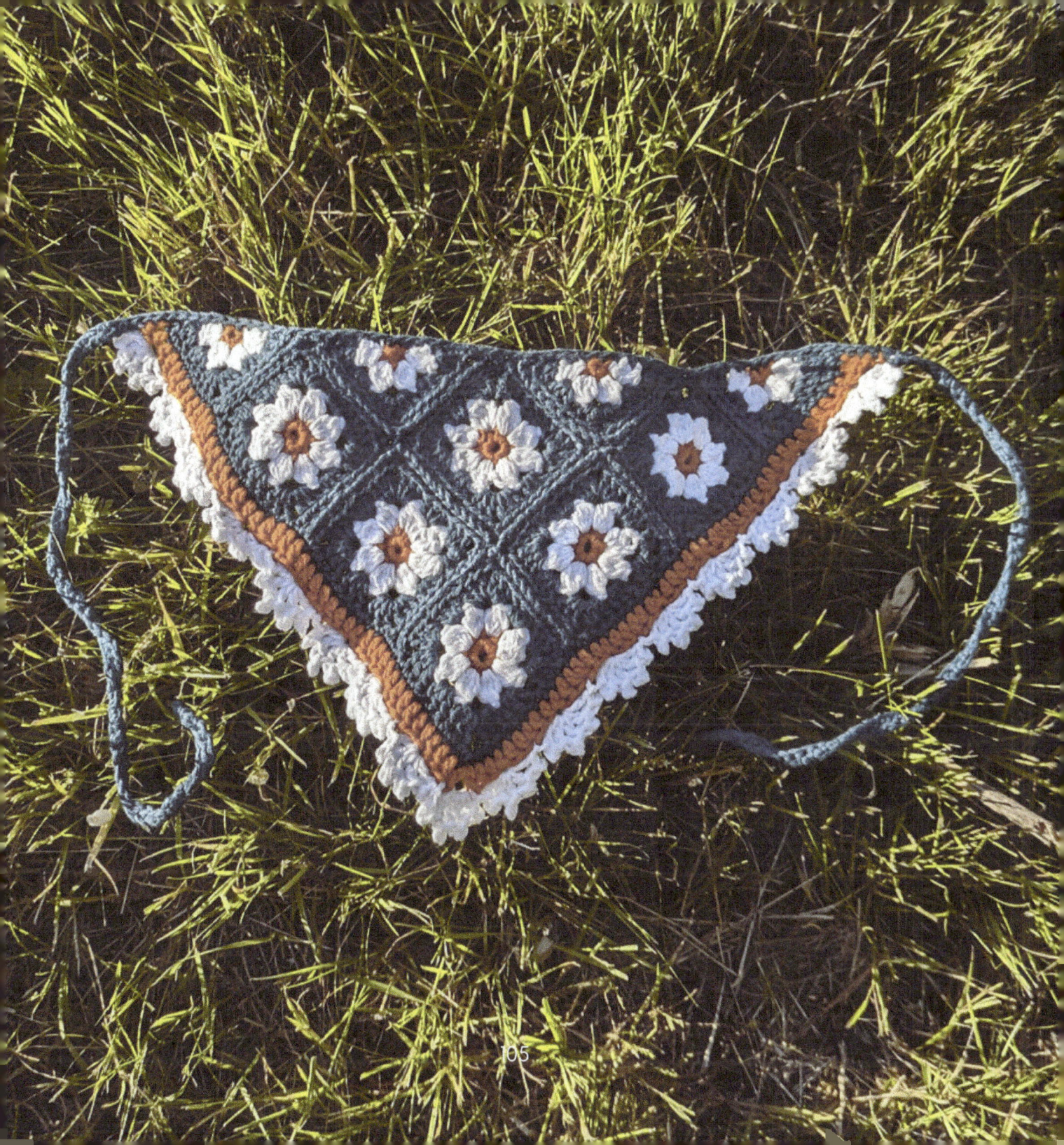

I want to express my sincere appreciation to all the readers of my crochet book. It offers an array of delightful projects that capture the essence of the season. From lightweight tops to beachy totes and colorful accessories, the possibilities for creating beautiful, functional pieces are endless. Whether you're a seasoned crocheter or a beginner, I hope this book has inspired you to embrace the joy of summer crochet and explore the endless creativity it offers. I am grateful for every stitch you've made from these patterns, every moment you've spent flipping through these pages, and every kind word you've shared about this book. Remember, the beauty of crochet lies not only in the finished piece but also in the process of creation. May your hooks always be busy, your yarns always soft, and your summers forever filled with the joy of crochet.

Warm regards,

www.ingramcontent.com/pod-product-compliance
Lightning Source LLC
Chambersburg PA
CBHW082237220526
45479CB00005B/1260